BASIL ALKAZZI

BASIL ALKAZZI

AN ODYSSEY OF DREAMS
A Decade of Paintings
2003–2012

Judith K. Brodsky, Curator

Foreword by Michael L. Royce

Essay by Donald Kuspit

Interview by Harry I. Naar

Published by
Scala Arts Publishers, Inc.
New York, USA

SCALA

Contents

Foreword

Michael L. Royce

When I arrived at the New York Foundation for the Arts (NYFA) in 2006 as the new executive director, one of the first things I did was to reach out to significant patrons of the not-for-profit to learn from them why they funded NYFA and to inquire if they felt engaged with the organization's mission. Though Basil did express thoughts similar to those of other patrons of the institution, I was delighted to find out that he was unique in two wonderfully distinct ways. First, he was our only patron who didn't live in the United States and second, he was also a distinguished artist, exhibited all over the world.

Here was a rare individual who not only beautifully and provocatively expressed himself through sublime creations but also committed his resources to helping out others. Realizing how fortunate I was in knowing such a person, I began to solicit Basil's feedback on many of the services and programs we provide to artists throughout the nation and globally.

Initially our communications were contained within digital means, and remained so for almost a year, until faced with a certain dilemma that required we speak in person. Basil picked up the phone and I relayed my concern to which he openly welcomed a conversation surrounding the matter. I did not know then that we were to begin a lifelong friendship that would extend beyond the material elements of living and into the spiritual.

I soon began finding myself delving into many conversations with Basil on all aspects of life and growing ever more aware of his wisdom, kindness, and compassionate objectivity. At some point I started referring to him as my angel for I felt and still feel that is what in fact he is: a warm assuring presence whose humanity is expressed through enveloping paintings and films, generous acts, and carefully thought out speech that guides one to a better self.

It was not until 2010 that I met Basil in person. He had come to town to give out a significant monetary award, which he funded, and named in his honor, to two excellent painters residing in New York. Being the man that he is, he arranged an

elegantly exquisite dinner for the recipients and some dear friends. Because it was his first time back in New York after many years, his schedule was filled to capacity, yet he still found time to invite me, four days later, to a lovely unhurried lunch at the Mandarin Oriental Hotel overlooking Central Park. I did not see him again for another two years. During that time, I continued to seek out his advice on all the subjects that took up space in my mind. Each one of them was graciously responded to.

On the day that we met once again at the same hotel, a particular organizational challenge was taking up all of my attention. As I stood in the open space before the entrance to the restaurant, solely focused on the emails going back and forth on my cell phone, I did not notice his quiet approach or pick up on the fact that he was standing behind me patiently waiting for me to conclude. Upon finishing, and noticing that it was 10 minutes past the hour, I quickly turned around to scan the room while rushing towards the maître d' to find my table. From behind, I heard my name being called out. I pivoted towards the lyrical sound and there he was, smiling with extended arms. We gave each other a big hug and then ambled over to our seats.

It was one of the most delightful afternoons I have ever experienced. As we said good-bye to one another, I knew that it would be a very long time before I was to see him again. Walking back through the crowded streets filled with people scrambling about, I felt there was a theme or an underlying message to our conversation that kept popping up but was never actually stated. It took me a few days but I finally figured it out: love. Basil is a man whose core belief is that all actions and words should come from the root of love and that, in fact, is how he lives his life. His paintings go in many different directions and evoke many different feelings but I believe they all illuminate one thing in common: love. May those who stop to contemplate his work find the same man as I did, for the outcome can only be an uplifting send off to a higher ground.

Preface and Acknowledgements

Judith K. Brodsky

I was honored to be asked by Michael Royce, the executive director of the New York Foundation for the Arts (NYFA), if I would be interested in curating this exhibition to celebrate the art of Basil Alkazzi. I immediately and enthusiastically agreed to do so. I have known Basil for at least 25 years and I welcomed this opportunity to curate an exhibition of his work from the past decade. I want to thank him for giving me this chance to pay homage to him and for making himself available throughout the months that have preceded the exhibition and the publication of the catalogue. It has been a pleasure to have reason to look at his compelling paintings almost every day over these last few months and to work with Basil on the aspects of the exhibition.

This exhibition is happening because of the friendship between Basil Alkazzi and Michael Royce. Before Michael became director of NYFA, Basil was already supporting the New York Foundation for the Arts in its efforts to assist artists in their careers, but subsequent to Michael's appointment, Basil's relationship with the Foundation has deepened, with the result that Michael suggested it was time for Basil to have an exhibition of his recent work and that NYFA would like to help implement it. Michael and Basil discussed my involvement, since I was the board member with the most curatorial experience in the visual arts. Basil's commitment to NYFA is so strong that he has designated that the income from the sale of this catalogue benefit NYFA.

A prolific and compulsive painter, Basil Alkazzi has a long and distinguished career spanning four decades from 1973 to the present. He exhibited regularly in London from 1978 to 1987 at the Drian Gallery, whose director, Halima Nalecz, jump-started many important artistic careers. His work was also included in the annual exhibitions of the National Society of Painters, Sculptors, and Printmakers from the 1970s through the 1990s, as well as in exhibitions at other venues such as the Contemporary Art Fair, Bath. Since 1985, Basil has lived in New York at various times. From 1995 until 2000 he was granted residence in the United States under the immigration rubric of "an artist of exceptional ability in the arts." His work has

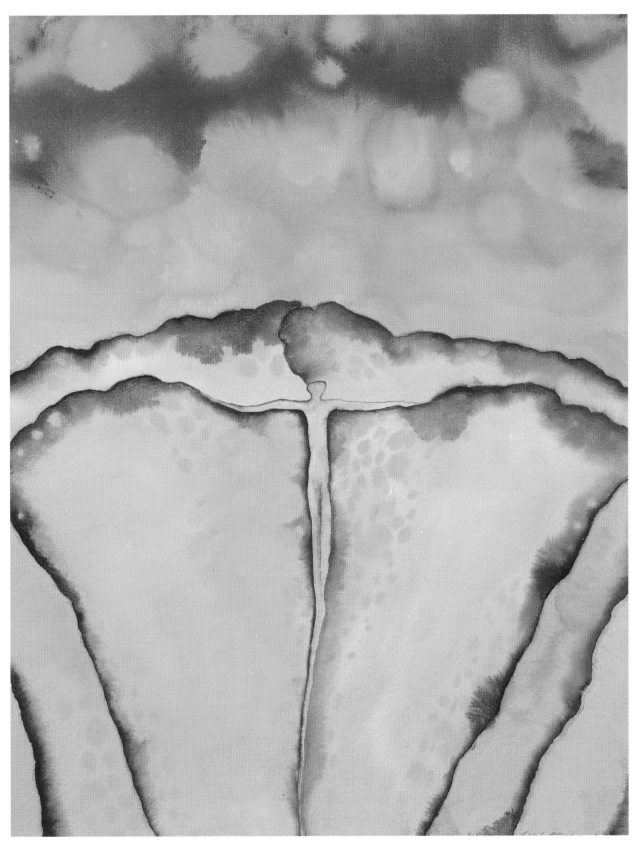

Ascension in Beatitude II

been shown throughout the country in museums and galleries ranging from New York City to Oklahoma City, Savannah, Las Vegas, New Orleans, Minneapolis, and cities in California. His work is in the collections of over two dozen museums in the United States including the Metropolitan Museum of Art; Neuberger Museum of Art, Purchase, New York; Hirshhorn Museum at the Smithsonian Institution, Washington DC; Santa Barbara Museum of Art and San Diego Museum of Art, both in California; Las Vegas Art Museum; San Antonio Museum of Art; New Orleans Museum of Art; Minneapolis Institute of Art; The Aldrich Museum of Contemporary Art, Ridgefield, Connecticut; and the Nelson Atkins Museum of Art, Kansas City.

Basil's work has been the subject of solo exhibitions in Tokyo, Warsaw and Kuwait, and he has been represented in major international shows such as the *Biennale Internazionale dell'Arte Contemporanea*, Florence, Italy in 2001 and 2003. Early in his career, he participated in the *Xlle Grand Prix International d'Art Contemporain de Monte-Carlo*, Monaco, in 1977. His paintings are in the permanent collections of the Tel-Aviv Museum of Art, Israel; The National Council, Kuwait; and Centrum Sztuki, Warsaw. Basil himself, as well as his art, has traveled around the world, first embarking on a four-month journey through North Africa, Turkey, and Greece in 1977, and more recently spending three months of cultural travel through Japan and Korea in 1994, The People's Republic of China and Tibet in 2007, and South Korea in 2009.

Basil has been interested in film for a number of years. In 1993, he wrote, narrated, and directed *Basil Alkazzi: New Seasons and Dreams 1984-1994*, a 21-minute, 16 mm film. His film, *Murmurs,* was a 2010 official entry at the Short Film Festivals in Barcelona and Chicago. In 2011, his film, *Prayers and Incantations* was an official entry at the Monaco Film Festival.

A number of books document Basil Alkazzi's art. Halima Nalecz's *Three Decades of Private Views at the Drian*, published in 1986, covers Basil's career as a

painter during his earlier period in London. His exhibitions in the United States are documented starting with *Mystic Dreamscapes: The Art of Basil Alkazzi* by George S. Whittet in 1988, followed by Max Wykes-Joyce's *New Seasons*, 1993. The distinguished critic Donald Kuspit has followed Basil's art over the years. Two books with essays by Kuspit appeared in 1998 and 2000, and I am delighted that Kuspit has continued to follow Basil's artistic evolution by contributing an essay to this catalogue. Another important book is Dennis Wepman's *Resonant Echoes: The Art of Basil Alkazzi*, 2007. Several of these books were published by K. Izumi Art Publications Ltd., Tokyo/London. Izumi also published *Journey to a Land Closer to Heaven*, a book issued in 2008, with narrative written by Basil and illustrated with his photographs taken during extensive travels through the People's Republic of China and Tibet in 2007.

His work is distinctive and personal and his recent paintings are quite remarkable. They are gouache and watercolor, but with their spectacularly intense coloration and their scale, they are quite different from what one would expect from that medium. Donald Kuspit's essay in this catalogue informs us of some of the significance and meaning of his work.

I admire Basil's art but I also admire Basil himself for his generosity as a philanthropist. His support of other artists is far reaching. In 1986 he established *The Basil H. Alkazzi Foundation Awards* at the Royal College of Art, London with an endowment set in trust and perpetuity. He himself continues to judge these awards, along with an invited guest co-judge. In 1987 he established *The Basil H. Alkazzi Award (USA)* for young and emerging painters in America. Two years later, *The Sheldon Bergh Award (USA)* was created for the best runner-up to the main award. The purpose of these awards was to give the recipients a means to withdraw and create a new body of work without outside pressure. Basil was personally involved in the selection of recipients and management of the funds.

Because these two awards consumed so much of his own creative time and energy, they were suspended in 2000.

I was on the board and eventually served as president of the College Art Association, and in the early 1990s was one of the people who established the Professional Development Fellowships for PhD and MFA students in their last year of study and first year after they receive their degrees. Basil made major gifts annually, in support of those fellowships from 1995 to 2007.

Now I am on the board of NYFA which gives grants to support visual artists, writers, composers, and choreographers. NYFA was established to do so in New York, but is extending its reach beyond the state to help artists across the country. Basil, again, has made a substantial gift to NYFA to support artists, in 2010 establishing two biennial awards, *The Basil H. Alkazzi Awards for Excellence.* Basil describes his reason for establishing the awards as follows: "We live in a fast moving culture that grows increasingly more abstract, away from the physical touch, away from the physical ground of being—away from the act of creation by hand. I want, in my own way, to encourage the glorious expression of pencil, brush and paint, and to nurture the kind of artist and the kind of art that I like and respect."

Basil does not limit his philanthropy to artists. Like his support of artists, his philanthropy is intended to further culture, social justice, and to help young people achieve their goals. Thus his philanthropy includes major annual support for Amnesty International UK and Mission Enfance, Monaco, just to name two examples.

In 2005, the Royal College of Art, London (RCA) conferred on him its highest award, Senior Fellow of the Royal College, in recognition of his work both as an artist and a benefactor of the arts. To mark the occasion, the RCA published *The Basil H. Alkazzi Foundation: A Commemorative Book Celebrating a Twenty Year Association with the Royal College of Art, London.*

Once again, I have had the pleasure of working with designer, Isabella Duicu Palowitch who not only designed the catalogue but managed the production. I also want to express my thanks to Donald Kuspit for writing the interpretative essay on Basil's work and to Harry I. Naar, professor at Rider University and director of the Rider Art Gallery for his interview with Basil. In addition I want to thank the directors of the galleries and museums in which the exhibition was shown: Les Christiansen, Bradbury Gallery, Arkansas State University; Cynthia Nourse Thompson, Anne Kittrell Gallery, University of Arkansas; Gerald Ross, director of the Galleries at the Maryland Institute College of Art (and also Gail Deery, professor and chair of the printmaking program at MICA for introducing me to Gerald); and Jorge Daniel Veneciano, director of the Sheldon Museum of Art, University of Nebraska-Lincoln. I should also like to thank Paul Baumann for his handmade frames; Greg Leshé for his excellent high resolution photography; Margaret Trejo for invaluable production assistance; book agents Jane Lahr and Lyn Delli Quadri; and Scala Arts Publishers, Inc.

Odyssey of Dreams: Basil Alkazzi's Spiritualism

Donald Kuspit

Dreams express that innate mental activity which thinks, feels and receives impressions, and engages in speculation on the fringes of our everyday activities at all levels, from the most carnal to the most spiritual, without our being aware of it. By revealing the psychic undercurrents and the requirements of a life-programme written at the deepest level of our being, dreams express the individual's most cherished aspirations and, incidentally, become an infinitely valuable source of all orders of information.

> **Roland Cahen,** *Le Rêve et les sociétés humaines.*[1]

The descent of spirit into the sphere of human consciousness is expressed in the myth of the divine *nous* caught in the embrace of *physis*....The religions should therefore constantly recall to us the origin and original character of the spirit, lest man should forget what he is drawing into himself and with what he is filling his consciousness. He himself did not create the spirit, rather the spirit makes *him* creative, always spurring him on, giving him lucky ideas, staying power, "enthusiasm" and "inspiration." So much, indeed, does it permeate his whole being that he is in gravest danger of thinking that he actually created the spirit and that he "has" it. In reality, however, the primordial phenomenon of the spirit takes possession of *him*, and, while appearing to be the willing object of human intentions, it binds his freedom, just as the physical world does, with a thousand chains and becomes an obsessive *idée-force*.

> **Carl Gustav Jung,** "The Phenomenology of the Spirit in Fairytales."[2]

The interpretation of dreams is the royal road to a knowledge of the unconscious activities of the mind.

> **Sigmund Freud,** *The Interpretation of Dreams.*[3]

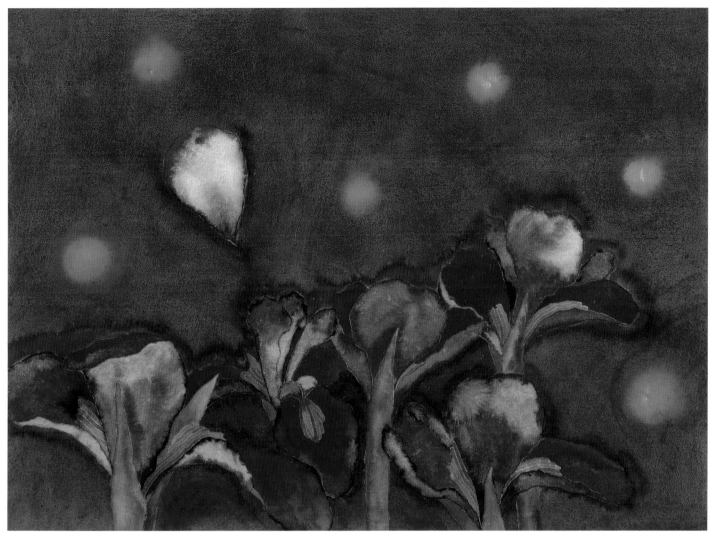

Iris and the Grasshopper that Flew Away

What is one to make of the range of works in Alkazzi's oeuvre? Is there any consistency in his development, any thread of concern that links them, any consciousness common to all of them—or rather anything unconscious that they have in common, that underlies the consciousness of body and nature evident in them? If, as the title of the exhibition suggests, his life is an "odyssey of dreams," is he then an artistic Odysseus, wishing to return home, and dreaming all the adventurous way?

Alkazzi begins the 1960s making a series of figures, all more or less abstract. *Portrait* and *Christ Crucified*, both 1960 are hardly identifiable as such, each being no more than a stem-like vertical supporting a cup-like horizontal, more or less featureless. We could be looking at a flower or goblet, or both condensed in one form, considering that condensation is one of the mechanisms at work in dreams,

as Freud has shown. The isolated "figures"—presumably human bodies, however strangely unhuman their bodies—are peculiarly iridescent, as though inwardly luminous. It is as if the blackness surrounding them has infected them. Both works are morbidly barren and melancholy, although the *Portrait* is toned with heavenly blue, overcast so that its luminosity seems veiled, not to say repressed. Four figures, all tersely drawn as though by a child, as their eccentric simplicity suggests—*Youth and Bird* and *Mother and Child*, both 1962, *Figures in Landscape,* 1963, and *Mother and Child IV*, 1964—reverse the figure/ground and light/dark relationship. The figures are now pitch black, and nominally representational as well as abstract sketches—their bodies are clearly human, however crudely schematic— and set in the paper's empty white space, so that they dramatically stand out, as though invested with instinctive urgency. In the mid-sixties the melancholy mood remains, as *Nocturnal Landscape* and *Pregnant Woman and Bird*, both 1966, show, but in the late sixties Alkazzi begins to lighten up—almost. In *Lovers in Saida* and *Transmutation of Lovers I* and *II*, all 1969, the sky above the lovers is half blue and half black, the earth below them is brown, like their glowing-in-the-dark bodies. They are a little fuller than those in *Figures in Landscape*, but, like the other figures in the early sixties works, all but bare bone, and smaller in the vast, seemingly infinite space of the barren landscape. The Lilliputian figures seem to be anxiously engaged in a furtive sexual ritual. But with the *Old House* images of 1970—ending an old decade and beginning a new one—a new openness and fresh light take over the picture, and abstract form (geometrical) and realistic representation converge, suggesting a new aesthetic sophistication. Similarly, with the 1974 *Desmond* Series, the body becomes unequivocally human, anatomically correct, and defined in some detail. It loses its abstractness and anonymity—abstractness and anonymity go together. We are looking at an individual, not a primitive sign.

In the early eighties, beginning already with *Moving Path Awaiting the Moment* and the *Birth Series*, all 1979, what I want to call a spiritual breakthrough occurs in Alkazzi's work. Pure forms, geomorphic and biomorphic, become emblematic of

pure spirit in action—pure spirit in Kandinsky's sense of being possessed by "inner necessity" and in Jung's sense of being possessed by "divine *nous*." Such works as *Look, See, Listen to Moments Cast Within the Seal*, 1988, *Ascending Angel*, 1996, and *Sea of Spirit Dreams*, 1997, make Alkazzi's spiritual intention clear. Perhaps most startlingly, Alkazzi's persistent focus on Christ's two hands, holding the goblet of wine, and isolated in blackness—in effect what mystics call "the dark night of the soul"—in the resolutely realistic *Last Supper Series*, 1992, clearly conveys his belief in the sacred. This *tour de force* series is followed by another that includes *Moments within Moment of Love Transmuted* and *Transmuted Beatitudes* among other geometrical abstractions made between 1989 and 1991, and anticipated in earlier works of the 1980s. These works have their place in the tradition of mystical or transcendental abstraction inaugurated by Kandinsky. And yet another sequence—the gloriously picturesque collages and photomontages of 1994, realistic fantasies which in my opinion have a special significance in Alkazzi's oeuvre. And finally, in yet another consummate group of works, the pantheistic "dreams of nature" that began in 2006 and continue to the present day. All these works, however different in style and method, are spiritually confident in a way the earlier works were not.

This brief, incomplete tour of Alkazzi's works—I'll return to some of them later—suggests his basic, recurrent themes: nature, the human body, love, and birth, all spiritual in import. The early works involve what have been called "trials of the soul on its spiritual journey"—"crises related to the person's efforts to break out of the standard ego-bounded identity,"[4] or, as Jung puts it, a journey from ego to self, a journey of self-realization—and the later works show the journey finally and successfully completed, the self spiritually at home and one with itself. Alkazzi's "odyssey of dreams" is a spiritual odyssey: his early works are spiritually suggestive, that is, involve what might be called presentiments of spirit in the body and nature, evident through the abstract transcendentalizing that compromises them, while his later works show them possessed by spirit, in Jung's sense, that is, divinely

inspired and enthusiastic, being enthusiastic originally meaning possessed by a god. Their numinous character suggests as much.[5] The psychoanalyst Henri Ellenberger has famously argued that all significant creativity emerges from what he called a "creative malady,"[6] suggesting that Alkazzi's later work is the creative cure for the malady that seems evident in his earlier work.

For Alkazzi the aim of art is spiritual enlightenment, an aim realized in all periods of art, from antiquity, as the ancient sculptures of humanized deities he quotes in some of his collages and photomontages show, to modernity, as his abstract renderings of nature show. Just as the ancient sculptures integrate numinous and natural experience of the human body, making it seem ideal without denying its physical reality, so Alkazzi's abstract images of nature idealistically "numinize" it without denying its physical reality. The body and nature acquire a presence they do not have in everyday experience, confirming that they are sacred and extraordinary.

Initially Alkazzi's nature is desolate and sterile like a desert, suggesting the desert of his father's Arabia and his mother's Kuwait. Animals sometimes appear in the desert, seen from a distance as though to confirm its vastness. Later, nature becomes fertile with colors and flowers, like the South of France, where Alkazzi now lives. One might say he's gone from one extreme to another—emotional as well as physical extreme, for the later works seem more intimate than remote. Similarly, Alkazzi's later bodies are bigger, more full-bodied and muscular than the earlier bodies, which are sort of token bodies, signs of the body with no visceral presence, self-evidently so in *Lovers*, 1963. Finally love, which seems like an impersonal, desperate physical act in the early works, becomes personal and, one might say, spiritually relaxed, intimate, and caring in the later works.

But life begins with birth, and Alkazzi depicts the moment of birth with exquisite delicacy in a number of abstract fantasies. The infant emerges from the darkness of the womb into the light of day, although sometimes it is stillborn and the light is moonlight, as in *Life and Birth of a Dead Foetus*, 1966. In this work, along with *Pregnant Woman and Bird* and *Mysteries of Nocturnal Landscape*, luminous

lines and amorphous shapes—forms that seem in metamorphic process—are isolated in black space, as though in an abyss. The embryonic forms, still incompletely differentiated, hang between life and death, suggesting that the outcome of birth—whether of art or life—is uncertain. These works are surreally intimate, ingeniously evocative of the trauma of birth, for many psychoanalysts the model for all traumas, for it involves expulsion from the paradise of the mother's womb, and with that literal separation from her body. Birth is thus a catastrophic break in the continuity of being, as the psychoanalyst Donald Winnicott wrote, and with that, paradoxically and unexpectedly, an experience of death. One unconsciously feels that one is dying at the moment one is being born. Thus the eternal darkness of death surrounds the small light of growing life in Alkazzi's birth pictures. The small moment of "enlightenment" in the nocturnal landscape has Gnostic import; one must "see the light" in the darkness to save one's soul. One can regard Alkazzi's odyssey of dreams as a journey from darkness to light—from a nocturnal landscape, in which nature is empty and deserted, the figures a small oasis of light in it, to a sunlit landscape, in which nature is flourishing and full of light, ensuring that everything—organic or inorganic, human or not human (animal, vegetable, or mineral)—has a soul as well as a body. Nature is mothering—empathic and energetic—in the sunlit landscapes; in the nocturnal landscapes she is apathetic.

No longer a part of one's mother's body, one begins to realize one has a body of one's own—pathetically small and helpless, as in the 1978 *Birth Series*. Similar small bodies, now engaged in sexual activity, appear in Alkazzi's early lovers works, suggesting that love is unconsciously regressive, for it involves the intermingling of bodies, thus unconsciously recalling the intermingling of mother and infant bodies during pregnancy. Indeed, making love is a "pregnant" moment—symbolically pregnant with unconscious meaning, to use Ernst Cassirer's phrase—and can lead to pregnancy. Freud regarded the oceanic experience of mystics as a symbolic return to the mother's womb, reminding us that life began in the ocean, and birth is signaled by the breaking of the mother's water—that without water there is no life, perhaps

suggesting the unconscious reason that Alkazzi lives near the Mediterranean Sea, its waves reflected in his ecstatic nature imagery of the last decade. With subtle bizarreness Alkazzi captures the moment of birth, when we are vulnerable and anxious but also strangely innocent, for we do not know what is happening to us. I think it requires a certain mystical genius to make these works, if mysticism involves "obscure self-perception," as Freud suggested.[7] Mysticism involves great capacity for inwardness, the sustained ability to stay in touch with one's unconscious, and by way of that, with the collective unconscious, and imaginatively and consciously externalize the unconscious in and through art, and thus numinously communicate it to others, putting them in touch with their unconscious, making them aware that they have a certain capacity for inwardness. Theorists as different as Anton Ehrenzweig and Edward O. Wilson argue that convincing art has an emotional impact on us before we understand it, and even if we never do, and Alkazzi's images make an emotional impact on us whatever their cognitive meaning.

I've mentioned that I think Alkazzi's collages and photomontages have special significance in his oeuvre. They're consummately beautiful; different elements harmonize in a garden of paradise, sometimes mountainous, sometimes a *hortus conclusus*, always serenely vital. For all the activity and crowds of people in *At the Beach*, a memory of Alkazzi's visit to Japan, the figures are happily together, whether seen up close at the banquet table in the foreground or in the crowd in the distant background. Wherever they are, they are all very particular individuals, all young, all enjoying life. Even when, as in *The Rape*, the picture fragments into physically incompatible parts, reminding us that "there is no excellent beauty that hath not some strangeness in the proportions," as Francis Bacon wrote,[8] it remains self-consistent emotionally. The parts are all actors in the same violent drama. But what makes *The Rape*, and all the other collages and photomontages particularly interesting, is their quotation—postmodernists would say appropriation—of historically important works of art. Some are modern, like Manet's *Déjeuner sur l'herbe*, 1863, which alludes to Giorgione's traditional *Pastoral Symphony*, ca. 1508,

and is the centerpiece of *The Rape*. Two of the heads, one of a naked female, the other of a clothed male, from the Manet make a brief appearance in *Landscape of Dreams V*, another collage.

Other appropriations are ancient, like the archaic sculptures of Apollo and of Kleobis and Biton, two standing male youths (*kouroi*), in a garden of paradise, inventively pictured in a 1995 collage. They stand in the foreground, the Apollo in the middle ground, and in the background three other naked male figures stand together, the two made of bronze shown back and front, one made of stone like the Apollo, Kleobis, and Biton figures, all more mature and classical in style than they. It is as though we are looking at three male Graces rather than three female Graces. The fragments of a sculpture of a male figure stand in the center of the work. It is as though they have been recently excavated from the past, and are waiting to be put together in a glorious whole, like the other figures. But the disconcerting fragmentation of the figure suggests it may be a discombobulated modern sculpture. It's springtime in the garden—the flowers, many pure white, are in full bloom, and the foliage is radiantly green. All the figures are handsome and statuesque, majestic and sacred, in the prime of life, their bodies perfect and healthy—whole and wholesome, unlike the absurd "modern" sculpture. They are presided over by what seems like a mother goddess, a few strands of luminous gold draping her naked brown torso and one arm. In other pictures the feminine makes its presence felt in the colorful petals that hover in the air, levitating like spirits. In still other pictures a rather grand—enormous—female head presides over the scene. In yet others two female figures, solid classical goddesses or ghostly Elizabethean ladies, watch over the male figures, caring for them as Mother Nature does.

These pictures are strikingly haunting, and archeological dreams in more ways than one. Like all dreams they are wish-fulfillments, and the wishes they fulfill are sexual and narcissistic. The archaic Apollo is Alkazzi's self-symbol, and the *kouroi* standing together are male lovers, like the earth-colored figures in *Seascape with Figures I* and *II*, *Angel and Lover III*, both 1980, and *Transmuted Lovers*, 1984. In

the last image they are inseparably intertwined, even more totally connected than
the figures in *Mother and Child IV*. There is a similar intimacy, involving narcissistic
mirroring, as true love always does (if only in fantasy form), in *Metamorphosis—
Spirit Artist—Reflections and Dreams*, 1995, which alludes to Pliny's account of
the origin of painting, which involved "tracing the shadow of a man with lines."[9]
Alkazzi's manly lovers are in effect shadows of each other, however different the
manner of representation of the 1980 and 1995 lovers.

I suggest that these representational works, along with such abstract works
as *Interpenetrating Triangles/Ezra*, 1994—one among many similar works showing
intersecting triangles, made at the same time or earlier—involve what Ellenberger
calls "sexual mysticism."[10] In some works the triangles are surrounded by a halo
of stars, making the mystical point clear. Sometimes bands or lines of white light
intersect to form a triangle. The triangles are all equilateral: "Equilateral triangles
symbolize the godhead, harmony and proportion. Since all procreation proceeds
from division, humans correspond to an equilateral divided into two, that is, with
a right-angled triangle."[11] It is a strangely narcissistic moment, subliminally sexual,
like the moment pictured in *Metamorphosis—Spirit Artist—Reflections and Dreams*.
In a sense, Alkazzi's later works recapitulate the moment of birth depicted in his
earlier works, with the difference that self-love and self-reflection are enough to
make one creative. Broadly speaking, he is concerned with the rare moments in
which narcissistic and sexual mirroring become one gloriously divine moment, a
moment of self-realization in which one feels and becomes God-like. God has the power
to originate—what Jung calls "primordial spirit" and what Winnicott calls "primary
creativity." One might say that Alkazzi's art is a meditation on the primary creativity of
the primordial spirit called God, sometimes materialized in human form, at other times
immaterially abstract, a sort of self-referential sign of itself, but always self-contained,
and always seemingly parthenogenetically pregnant with life, as nature seems to be.
The pure godhead, inherently creative, is the dream home which his art finally reaches.

Bring two pure right-angled triangles "sexually" together to form an equilateral triangle and you have a mystical house of God. Indeed, sometimes Alkazzi's triangle is a temple—Alkazzi's earlier imperfect house transformed or, to use his word, transmuted into the perfection of a temple, much the way his lovers are transmuted into angels, that is, spiritual beings, and with that fully self-realized. Love becomes unequivocally spiritual in Alkazzi's later works, suggesting—as I want to do—that his works are religious icons, a point made explicitly clear by his *Angel*, *Three Angels*, and *Five Angels*, all 1999, and above all by the *The Last Supper Series*, stripping away all those who were present at it so that we alone can witness it, zeroing in on the hands that hold the goblet from which He drinks the wine that He miraculously transforms into His blood, and which bless us despite the fact that we have betrayed and denied Him, as Judas and Peter did. The medieval religious icons that Alkazzi quotes in a 1995 collage—they tell the story of Christ—make my point about his works being religious icons clear. A religious icon painting is a "sacred and venerated object...vested in the transformative and transcendent experiences of envelopment and ekstasis."[12] At its most consummate, sexual experience can be ecstatically enveloping, making it transformative and transcendent, that is, it seems to afford the same "access to another spatial and temporal dimension" that a religious icon painting does. This is what it means to be "transformed by love"— true love of another human being and especially of God—and to feel that one has "transcended" everyday space and time, experienced a "timeless and out of this world moment," confirming that one's body has "spirit." Sexual experience can be spiritually nourishing however physically depleting. It can be sacred, however seemingly profane. In Alkazzi's early nocturnal desert works it seems profane, in the later nature works it seems sacred. But in both works it is creative.

The lines in the upper part of the 1993 *Metamorphosis Series* intersect like the wings of an angel, and the triangle beneath them is in effect its body, or rather its disembodied pure spirit. Angels are pure spirits—invisible until they flash

in the sky, as it were, like the "comets" in the *Eternal Whisperings Series*, 1999, metamorphosizing into the ecstatically luminous organic forms in *The Rites of Spring* and similar "Spring Dreams" pictures, as I want to call them, that begin to appear from 1999 onward. They finally transform into the glorious flowers that begin to appear in 2006, heralded by the magnificent lily that appears in one of the collages. Like Mondrian's flower paintings they are sacred icons, but unlike Mondrian's flowers those of Alkazzi are not decaying and melancholy but jubilant and growing—not nature on its last legs, ready to be abandoned in Mondrian's geometrical abstractions, but nature full of joie de vivre, all the more so because it remains mystically abstract. Alkazzi's flowers are angels in another form, reminding us that angels are supernatural, immaterial beings able to give themselves natural, material bodies, thus miraculously revealing their presence. Alkazzi's works are revelations, and also make it clear that sex can be a spiritual revelation, as the Annunciation ingeniously suggests. The Angel Gabriel tells Mary—spiritually pure because she is a virgin and will remain one forever—that she will be impregnated by God (vicariously through the manly Gabriel?) and give birth to his Son, mysteriously becoming a mother, that is, creative, informed by the Holy Spirit, housing it in her body. The Annunciation suggests that all sexual acts are implicitly—potentially—spiritual, and all spiritual acts, including making art (certainly religious icons), are implicitly sexual.

A final comment, by way of Freud, about Alkazzi's portraits of Jack Woolley, Tim Powell, Carlo Piazza, Ronald Kuchta, Patti Palladin, and Eva J. Pape, among other people. All are convincing "speaking likenesses," but more to the point is that they are "dream portraits," in Freud's sense of the dream. "Dream-imagination," Freud wrote, "is susceptible in the subtlest manner to the shades of tender feelings and to passionate emotions, and promptly incorporates our inner life into external plastic pictures."[13] Alkazzi's portraits of friends are full of tender feeling and passionate emotions, suggesting his devotion to them, and suggesting the subtlety of his "artistic work," which is what Freud called "dream work."

Notes

1 Quoted in Jean Chevalier and Alain Gheerbrant, *The Penguin Dictionary of Symbols* (London: Penguin, 1996), 311.

2 Carl Gustav Jung, "The Phenomenology of the Spirit in Fairytales," *The Archetypes and the Collective Unconscious, Collected Works* (London: Routledge & Kegan Paul, 1959), II, 212-13.

3 Sigmund Freud, *The Interpretation of Dreams*, *Standard Edition* (London: Hogarth Press and the Institute of Psycho-Analysis, 1953), IV, 647.

4 David Lukoff, "Visionary Spiritual Experiences," *Psychosis and Spirituality: Consolidating the New Paradigm*, ed. Isabel Clarke (London: Wiley-Blackwell, 2010), 207.

5 For Rudolf Otto, numinous experience involves the feeling of "pious or religious dependence," and with that a sense of being in the presence of something tremendous and mysterious (the "mysterium tremendum") (Otto, *The Idea of the Holy* [New York: Oxford University Press, 1958], cited in J. J. Pollitt, ed., *The Art of Greece* 1400-31 B.C. [Englewood Cliffs, NJ: Prentice-Hall, 1965], 34. For many romantics—such as Alkazzi—nature is inherently numinous, arousing feelings of overpowering awe, involving the sense of being overpowered—and simultaneously empowered—by its energy, and submerged in or merged with its otherness. For Otto the numinous is a "unique... category of value" recognized when one is in a "'numinous' state of mind," suggesting that the capacity for numinous experience is innate to human nature (cited in Henri Ellenberger, *The Discovery of the Unconscious: The History and Evolution of Dynamic Psychiatry* [New York: Basic Books, 1979], 534). The numinous can also be felt in the human body, as the ancient sculptures, both archaic and classical, of the naked male body and the draped female body—gods and goddesses— that Alkazzi features in some of his collages make clear.

6 Henri Ellenberger, "The Concept of Maladie Créatrice," *Beyond the Unconscious: Essays in the History of Psychiatry* (Princeton: Princeton University Press,1993), 328-40.

7 Quoted in Ellenberger, *The Discovery of the Unconscious*, 534

8 Quoted in E. F. Carritt, ed., *Philosophies of Beauty from Socrates to Robert Bridges: being the sources of aesthetic theory* (New York and London: Oxford University Press, 1947), 56.

9 Quoted in J. J. Pollitt, ed., *The Art of Greece 1400-31 B.C.* (Englewood Cliffs, NJ: Prentice-Hall, 1965), 34.

10 Ellenberger (*The Discovery of the Unconscious*, 545) notes that "sexual mysticism" has a long history, traceable from Plato to Schopenhauer. It is inherent to romantic philosophizing about nature and cabalistic thinking. It is sometimes called "sexual transcendentalism," sometimes the "metaphysics of sex." It involves the assumption of "the fundamental bisexuality of humans." It is alchemically represented by a hermaphrodite, often standing in triumph over a dragon and worldly globe symbolizing chaos. The dragon symbolizes the threatening instincts, the worldly globe the chaos that results when they are allowed to run wild, overwhelming consciousness. But the circular globe contains a triangle, that is, the seal of the godhead, a sign of spiritual consciousness. The hermaphrodite symbolizes "the alchemical goal of coniunctio, the union of opposites (male and female, consciousness and the unconscious, etc.)" the dialectical ambition of the creative spirit. A famous illustration of "the philosophical egg" that is the "birthplace" and "container" of the creative spirit appears in Marie-Louise von Franz, *Alchemy: An Introduction to the Symbolism and the Psychology* (Toronto: Inner City Books, 1980) cited in Ellenberger, *The Discovery of the Unconscious*, 534. As Kandinsky wrote, "art in many respects resembles religion," for both belong to "the spiritual life," which "consists in moments of sudden illumination, resembling a flash of lightning," which helps us understand Alkazzi's alchemical art, all the more alchemically creative when it is abstract (eds. Kenneth C. Lindsay and Peter Vergo, *Kandinsky: Complete Writings on Art* [New York: Da Capo Press, 1994], 377, 131).

11 Chevalier and Gheerbrant, 1034.

12 Stephen James Newton, *Painting, Psychoanalysis, and Spirituality* (Cambridge, UK and New York: Cambridge University Press, 2001), 167.

13 Sigmund Freud, *The Interpretation of Dreams*, *Standard Edition* (London: Hogarth Press and the Institute of Psycho-Analysis, 1953), III, 118.

Interview with Basil Alkazzi

Harry I. Naar

Harry I. Naar Can you tell me a little about your family background and your history?

Basil Alkazzi "The past is a foreign country, they do things differently there."[1] My father's family originated in Unaiza, in Arabia which was then part of the Ottoman Empire. Orphaned at birth and an only child, he moved to Kuwait also under Ottoman rule. My mother's paternal family was from Kuwait, and her maternal family from Turkey. She too was an only child. They were very devoted to each other.

My own childhood within that household was not very happy.

HN Was there anyone in particular who played a role in directing your interest in the visual arts?

BA No one in the time you seem to refer to. Early on I found that I had a talent for drawing and painting. This sublimated my loneliness, as did reading. At boarding school in Beirut, Lebanon was where I both felt and knew that what I really wanted to do was paint. I read a great deal, books from the United States Information Service and British Council libraries; our English literature class and travels introduced me to the works of Eugene O'Neill, Tennessee Williams, Terence Rattigan, Charles Dickens, W. Somerset Maugham, and Daphne Du Maurier, amongst many others.

Much, very much later, yes. Halima Nalecz,[2] a fine artist in her own right and director of the avant-garde Drian Galleries[3] in London where I exhibited regularly for many years until my move to New York. She befriended me, encouraged me, guided me, and taught me about the pitfalls in the art scene. Max Wykes-Joyce, the art critic who became a good friend and mentor, also encouraged me to pursue my own path, irrespective of the trends and fashions. Both Halima and Max were spiritual and so there was that link and unspoken understanding, empathy, and friendship. I remained very close friends with both of them, their entire life-time.

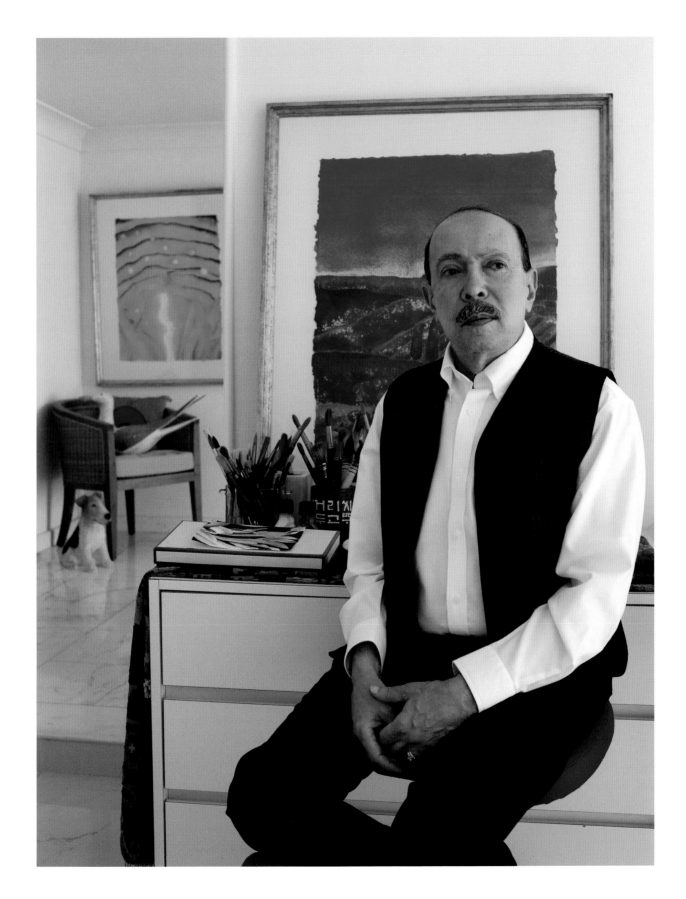

Much later Donald Kuspit's essays in their own way assured me that I was not working in total isolation. Here were people whose judgement I respected, and if they could see, and acknowledge my creativity, then that was all that mattered. And that, in reality, is all that does matter.

HN Were there any particular teachers at the art school you went to who played a significant role in forming your visual vocabulary?

BA I visited London from the age of 13, and started living there permanently at the age of 17, since when I have considered it my home. But London at that time in the 1950s was bleak. This was just after WW II and the smog was oppressive in winter. The school of art was not what I had hoped it to be. The teaching was very restrictive and controlled. It was a very difficult and painful period in my life. I could not conform to the rigidity, and I did not want to, not in my creativity, my only form of expression that gave me my freedom. This constant daily conflict was compounded by an equally oppressive life at home; and so I had a nervous breakdown. I was in hospital for many months.

HN In looking at your work through the years, you have tried a variety of different approaches. You have focused on direct observation, dream worlds, the cosmos and embodiments of philosophical ideas, and photomontages reminiscent of Dadaist imagery and the work of David Hockney. Can you talk about this development?

BA I did not wilfully approach a different subject or style. These evolved, by my own evolvement as a human being—living, thinking, always questioning, always seeking knowledge from *all* sources—and as a creative artist seeking to express myself; they evolved by my travels and sojourns in different countries. My paintings and drawings, are all, expressions of me, myself, my inner being, and you will always find a link, a thread, between one period and the next.

A few days after leaving hospital, a friend suggested I join him in Greece. I grabbed the invitation as my life-line. I purchased a train ticket from Victoria Station to Athens. We then spent a little more than a year in Greece, the majority of which was in Crete, giving English language lessons to pay our way. I drew and I read a lot at the time: James Baldwin, Henry Miller, D.H. Lawrence, and I myself started to write.

Back in London, I did odd jobs, still writing, drawing, and painting. I avoided going to galleries or exhibitions, wanting to create something from within myself. It is said that artists heal their wounds through their creative work and I possibly did just that. I would, and I still do, spend long periods of time contemplating paintings by the Italian masters: Giotto, Botticelli, Perugino, Fra Bartolommeo, and the English masters: Turner, Constable, Stanley Spencer. Although I admire their work, I never had a desire to emulate their style of painting or subject. It was not until I had painted *Old House, Old Doorway, New View,* which was in effect a portrait of myself in 1970, that I then started to send my work to group exhibitions beginning with the Chelsea Arts Society,[4] the oldest art group in London, and to which, if you resided in the Borough of Chelsea or Kensington, you could submit your paintings to their annual exhibition; and soon after I then came into contact with Halima Nalecz.

HN And the photomontages?

BA My photomontages came about, much, much later, in the mid-1980s, by accident and then for a brief period by choice. I had strained and badly bruised a tendon in my right arm; I could not hold a cup of coffee, pen or brush in my right hand for many months. I was feeling very frustrated as a creative person. I was in San Francisco at the time and I had gone to the San Francisco Museum of Modern Art and there were these photographic images by Max Yavano and Val Talberg as well as an exhibition *Hockney Paints the Stage.*

Walking back to my hotel from the museum I started to photograph the Painted Ladies of San Francisco, creating a montage as I did so; a form of creativity

was suddenly in my grasp, and this gave my stifled pent-up desire to create a means of release. That was how the photomontages came about. I was living in Greece at the time, and so I then went to Xania in Crete, and started to do landscape photomontages. When I went to London I showed these to Halima Nalecz who insisted that they be exhibited at the Drian Galleries, and so they were. This exhibition then traveled to the Sherkat Gallery in New York, thanks to Jane Wesman. I am indebted to Jane for her friendship and her many acts of kindness. A few years later prompted by Eva J. Pape, a fine lady, and like Halima a patron of the arts, and who was also curator of a number of my exhibitions, I embarked on a series of photomontage portraits, and these I found challenging in trying to express the persona of the sitter. I am very happy with many of these portraits.

HN What led you to select, at that time, such controversial writers as James Baldwin, Henry Miller, and D.H. Lawrence? Did they affect your creative process and what were you writing?

BA I like a good read, a high quality of writing in literature. You must remember, I was living in London, a huge metropolis, rich in culture, literature, theatre, cinema, all going through a flux, a metamorphosis. So many things were changing at that time, and when you are young, you yourself are part of that on-going change in which nothing is really controversial. Besides, I had also read Muriel Spark, Jean Rhys, Cavafy, Jean Genet, and many, many others. Yes, we had censorship in the United Kingdom at the time. Plays such as *Waiting for Godot* and *A Streetcar Named Desire* were banned, but, one could see them at The Arts Theatre Club, to which one became a member to a "private club" no longer "public," thus bypassing the censors.

Baldwin, because of his move to Europe, was often written about. He was also the first black American author of repute so it was right that one should read him. My travelling companion to Greece suggested I read Miller's *Tropic of Cancer* and

Tropic of Capricorn, which we could purchase in Paris at that time. D.H. Lawrence had become a mythic and romantic literary figure. And no, I don't feel these authors in particular affected my creative process. Reading after all was not all one did. There was the cinema: Vittorio de Sica, Rosellini, Elia Kazan, Ken Russell, Fellini, Pasolini; there were museums, exhibitions; there was *Jesus Christ, Super Star,* the theatre of Joan Littlewood, and Delaney's *A Taste of Honey*; George Devine at the Royal Court; John Osborne's angry plays, and so very much more. Yes, books certainly do enrich and expand our knowledge of life with very beautiful prose and yes books can influence how we think and feel and view the world around us, but so do films, theatre, friends, colleagues, lovers, travel, and so does life itself, and the conundrum of life.

What did I write? I wrote poems and short stories.

HN For some artists, changing styles, directions or experimenting with different ways to create an image has affected the way critics and the public may view their work. I can think of two artists, André Derain and Jean Hélion, who suffered at times because of this. Do you think changing direction or trying new approaches has affected the critical or public view of your work?

BA Yes. People did not, and perhaps still do not, like others to have multiple talents, or to express that talent in multiple forms. Galleries did not, and many still do not. Each art dealer/gallery owner "specialises" in a certain style, or ethnicity. The gallery is there to sell tomatoes, but if you put in a few leeks or zucchinis, even if they come from the same farm, they do not know how to sell them.

It is unfair to entrap and expect only one form of creativity from any creative artist. There is no high or low, no going out on a limb, as one must. Repeating the same established saleable image of subject or expression does not necessarily make one a master. I am grateful to my Muses for not allowing me to be trapped in that mould. The critics whose opinions mattered to me, George S. Whittet, Max Wykes-

Joyce, Donald Kuspit, Halima Nalecz my London gallery director who praised my range and fecundity, Kudo Izumi, Najat Sultan and others, never ceased to support the changes, and welcomed them, as part of my own evolvement, and the evolvement of my creativity and form of expression. Many of us did not agree to come on this Earth's journey only to paint tomatoes.

HN This exhibition of gouaches reminds me of the work of the Symbolist painters Emile Nolde and Odilon Redon and the British painter Samuel Palmer. Have you studied Symbolist paintings and if so, have the Symbolist artists influenced your vision?

BA No, I did not study Symbolist painting. I did, and still do, love looking at and contemplating the work of artists whose work is very different to my own, primarily the Italian and English masters.

I avoid visiting galleries or looking at books of art, or even socialising, when I am in the season or period of creativity. I go through such periods which will last a few or many months, where I paint, and paint, and that is basically all I do, until there is no more to do, nor any more energy for the Muses to work with or through.

In the fallow months I read a lot, now often re-reading Capote, Hardy, Chatwin and others; going to the cinema and theatre; and visiting exhibitions of artists who were recipients of my awards. I love visiting Florence and the Uffizi Gallery.

I paint in gouache and watercolour. I like this medium and still find it challenging. It is much more difficult and challenging than oils, a medium that was not really to my liking.

HN You have been a wonderful supporter of the arts and especially younger artists. Would you like to tell us the origin of this commitment?

BA As a Spiritualist I have always believed that one must give back for the blessings one has received. Life is a two way street. It is not a cul-du-sac. Halima, through her gallery, encouraged and promoted artists whose work she liked. I

emulated her by doing so through my Foundation[5] at the Royal College of Art in London, followed by other awards I created in the United States.

HN Your color and your design, especially in the travelling exhibition of gouaches, are truly beautiful and provocative. The color has the power of the Fauves, but not in an out of control or arbitrary way. In fact your color reminds me of the expressive and symbolic qualities of Wassily Kandinsky and the dream-like qualities found in a Mark Rothko. Can you comment on this and explain the role color plays in your cosmology?

BA It is a huge compliment to be likened to Rothko or Kandinsky in any manner. However, after painting for so very many years, I no longer "think" about colour, but allow my instinct and my Muses to determine them. Sometimes when I have finished a painting, I find myself deeply grateful at how beautiful the finished work is.

HN How did you begin these watercolor-gouaches? What stimulates or supplies the impetus for you to create a particular image? Do you work directly from life, from a drawing or photograph or do you create an image in a more spontaneous way?

BA I don't feel I create "a" particular image. My work is not representational, so of course I do not work from photographs, nor directly from life, except when I do life drawing as an exercise. In my mind's eye I see a visual image of a thought, and I may make a sketch in order to remember that as a reference to a starting point, but once I start, the actual act of painting, my Muses then determine what I do, and when this does happen, then, and only then, do I feel that my work is good. I am very critical and objective of my own work. Not all that I create is worthy of being exhibited, much has to remain in the studio, some to be destroyed.

HN The gouaches in this exhibition depict flowers, not in a literal way but more in a mystical, spiritual, and symbolic way. Do you agree with this comment, and, if so, can you tell me what these images mean?

BA Yes, a metamorphosis has taken form. I have always been deeply involved in spiritual matters. I am not a man of religion, but of faith, and I have always believed in Spirit entities, in the life of a soul that continues to live in Spirit form. My paintings of nature are the *Life-Force* embodied *in* nature, *all* of nature, and that includes mankind. I like looking at, and have always liked looking very closely at, how a plant grows from a seedling, at the way a bud sprouts, a leaf uncurls, and then another, and the petals open. I enjoy watching them being born, and blossoming. I can and do spend long periods of time gazing at the sky, the sunrise, the shifting light on land and sea, cloud formations, the ebb and flow of the tide, gulls flying, and the dazzling green fields of any countryside of our very beautiful planet Earth.

HN The Spanish writer Jorge Luis Borges comes to mind when looking at your gouaches because he was able to transform and interweave a story from a natural objective world into a world that is dream-like and filled with mystery. Do you feel that there is a relationship between your art and writers like Borges? Which writers or philosophers have been meaningful to you in the development of your ideas?

BA I have not read the author you mention. I don't think there are any writers in particular of this genre who have influenced me or been meaningful to me. I studied Cabbala for a short time and delved briefly into Sufism, but neither garment clothed me comfortably.

HN I understand that you sometimes listen to music in your studio. How does music play a role in your creative life? What kind of music?

BA I do not listen to music when I paint. I do however listen to classical music almost always.

I love the cello in classical music; I like Grieg, Handel, Bach, Mozart, Bruckner, Tchaikovsky, Puccini, and so many others.

Classical music allows me to move away from the outside world, into my own world, which is when I then reach out, in my studio, and ask my Muses to help me, and they come, they enter, they whisper, and it all comes to me, it flows to me and then it flows through me, and I paint, to the sound of rain or wind, the cry of gulls, perhaps, the chirping of a passing sparrow, and silence.

HN You have travelled and lived in a variety of countries. How has this experience affected your artistic vision?

BA Travel, especially of long durations, opens vistas and very human contacts. To actually look, see, and contemplate the many dazzling beautiful parts of our Earth; to see, feel, eat and live as much as possible as the indigenous people do, is very enriching to both the body and the mind, and the soul. To connect to and with different races, cultures and foods, is infinitely liberating. Such experiences were very possible in the 1960s and 1970s before the onslaught of mass tourism. It must and does enrich and affect one's creativity if one is both open and receptive to both unconditional knowledge and change.

HN What do you want the viewer of this exhibition of gouaches to recognize or come away with?

BA Awe at the sublime Soul within Life, and nature, and so, within themselves.

Notes

1 This is the first line from L.P. Hartley's famous novel, *The Go-Between*, first published in London in 1953 by Penguin Books.

2 www.Halimanalecz.com

3 www.Drian-Galleries.com

4 www.ChelseaArtsSociety.org.uk

5 www.basilalkazzifoundationrca.com

All quotes by the artist.
Details on left hand pages reproduced at original size.

2003–2012 Plates

2003

To be born, as one is born, in the middle of the ocean, on the crest of waves, in the womb of the night, after midnight, to drift on, kissed by moonlight, towards a shore, a distant unknown port; to drift on, waiting for the dawn, to then be kissed by the sun, and the sea, and the waves are still there, and still no sign of land, except that deep within the ocean bed. How then can the Soul not kiss and embrace, as the sea does, so very many different shores? Was it that the waters that embraced one's birth, now embrace and drift one towards shores of their choice, of their love, and so, of my love?

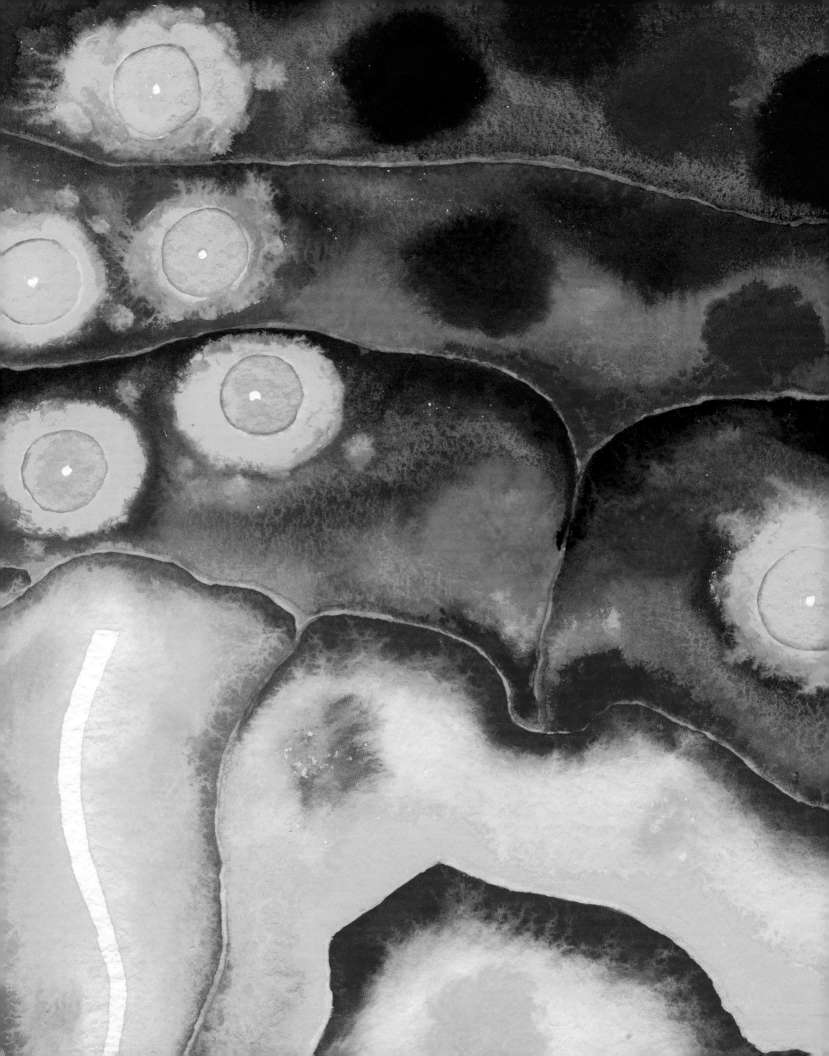

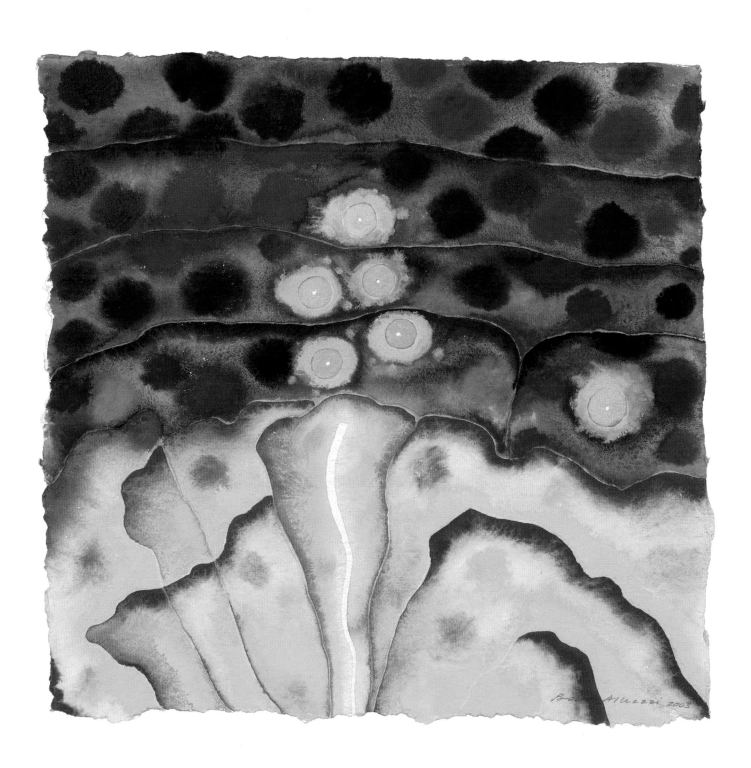

Blossoming Spring III

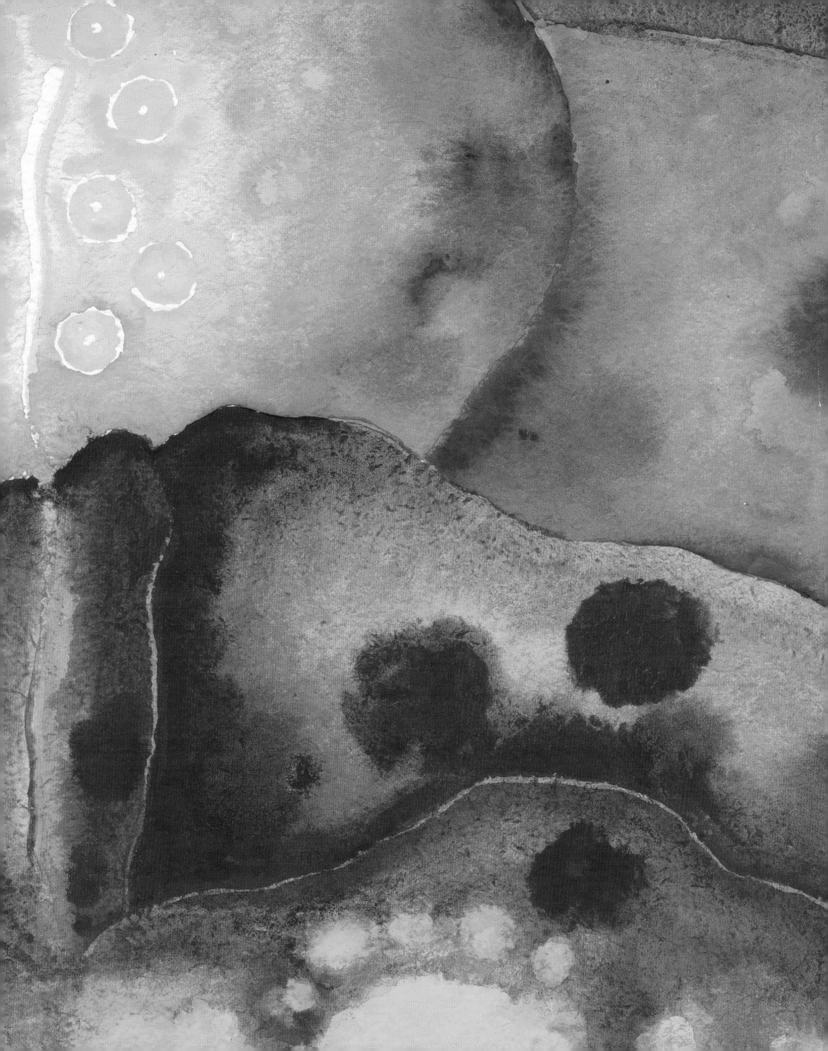

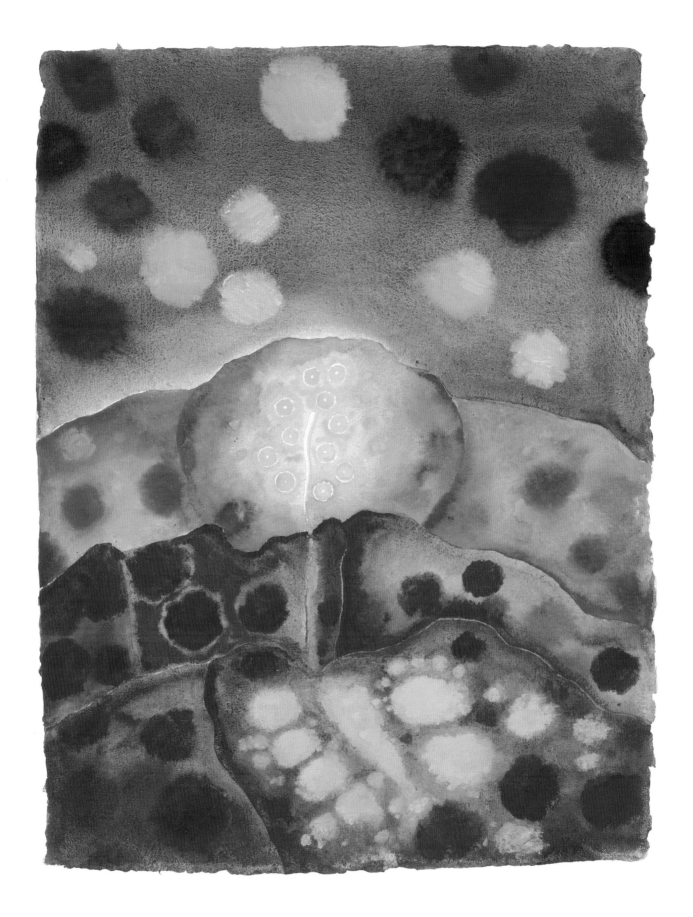

Kiss of the Butterfly IV

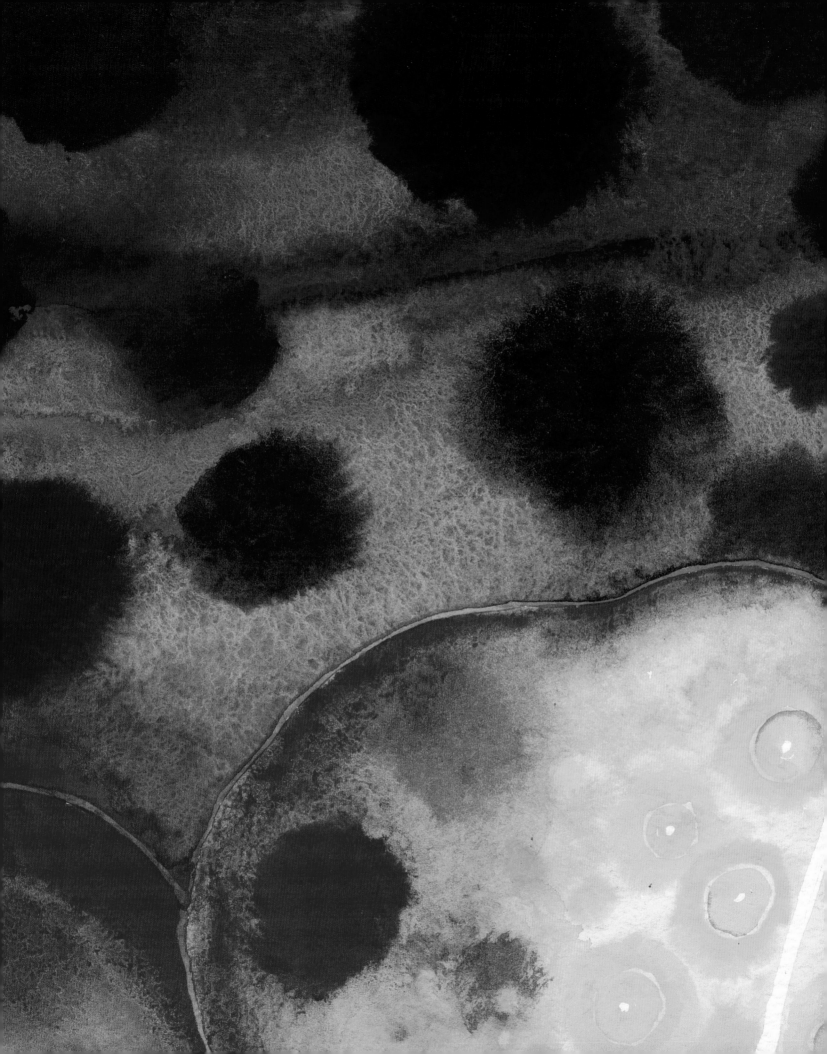

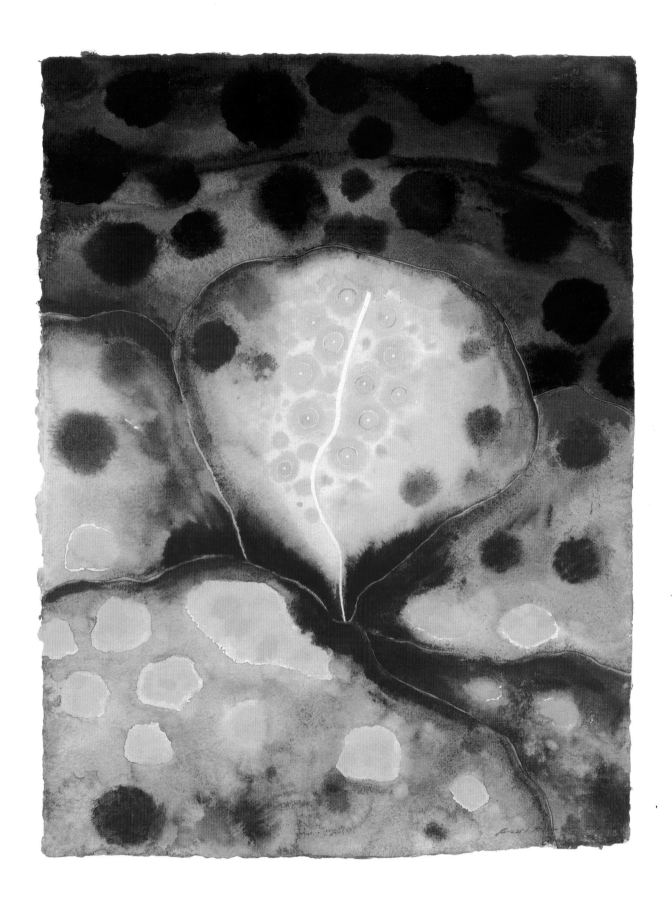

Kiss of the Butterfly V

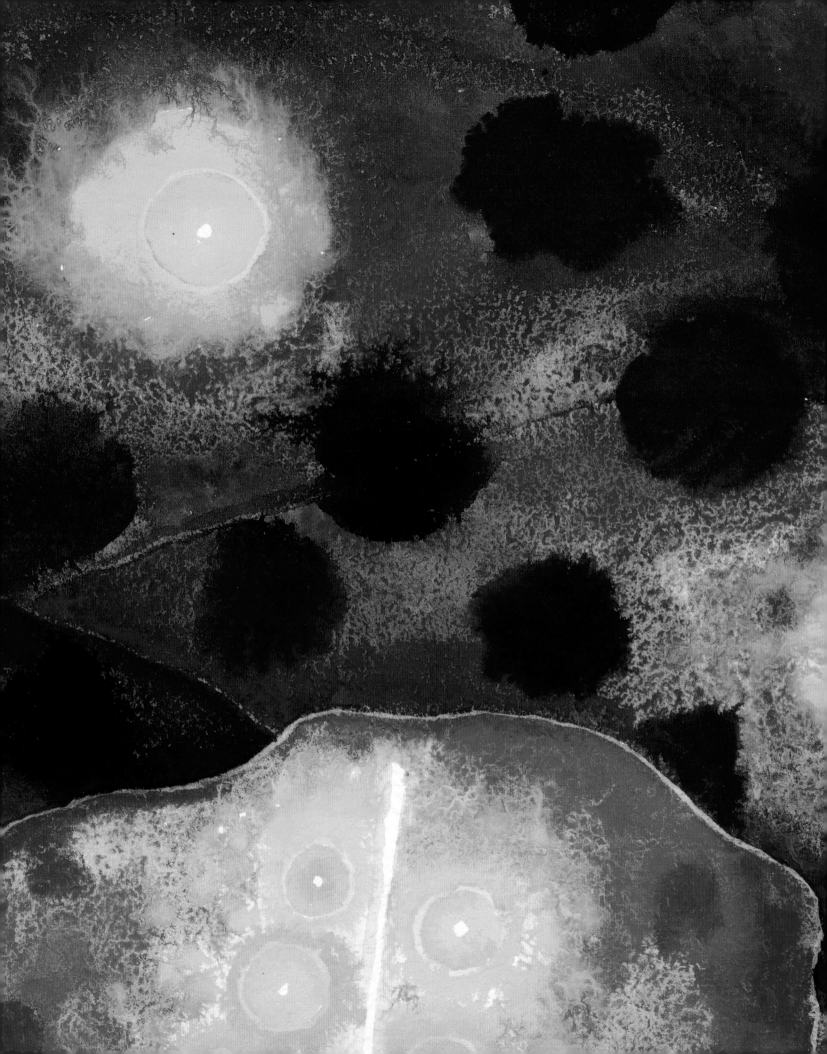

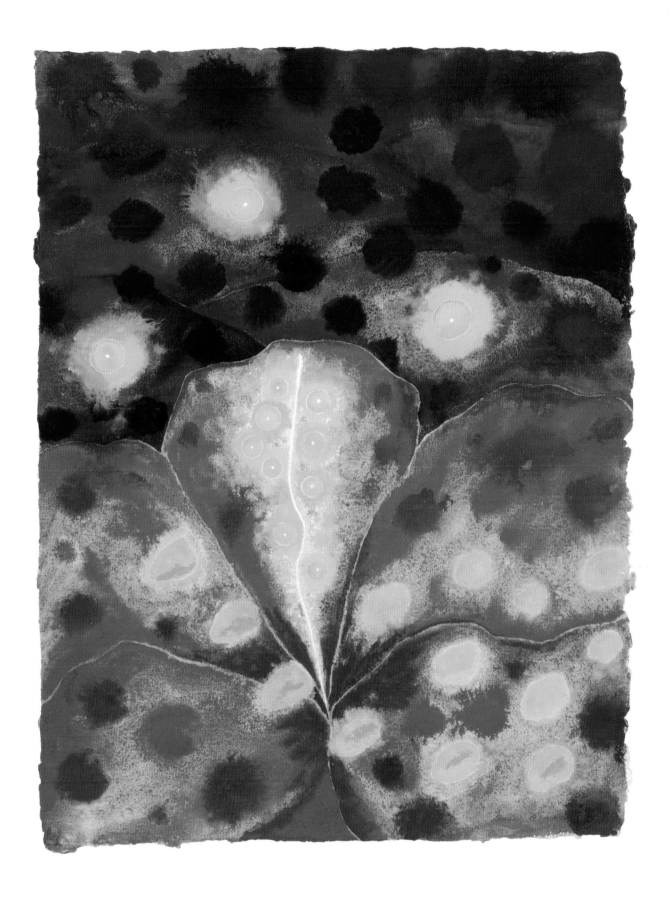

Kiss of the Butterfly VI

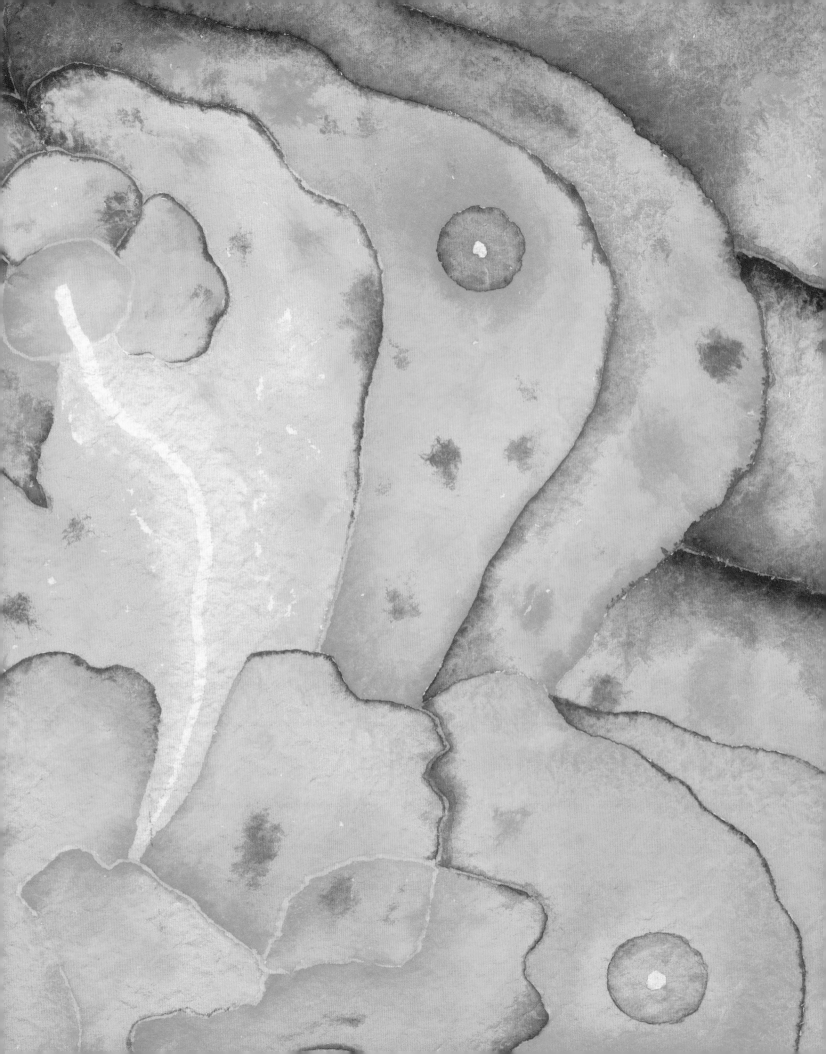

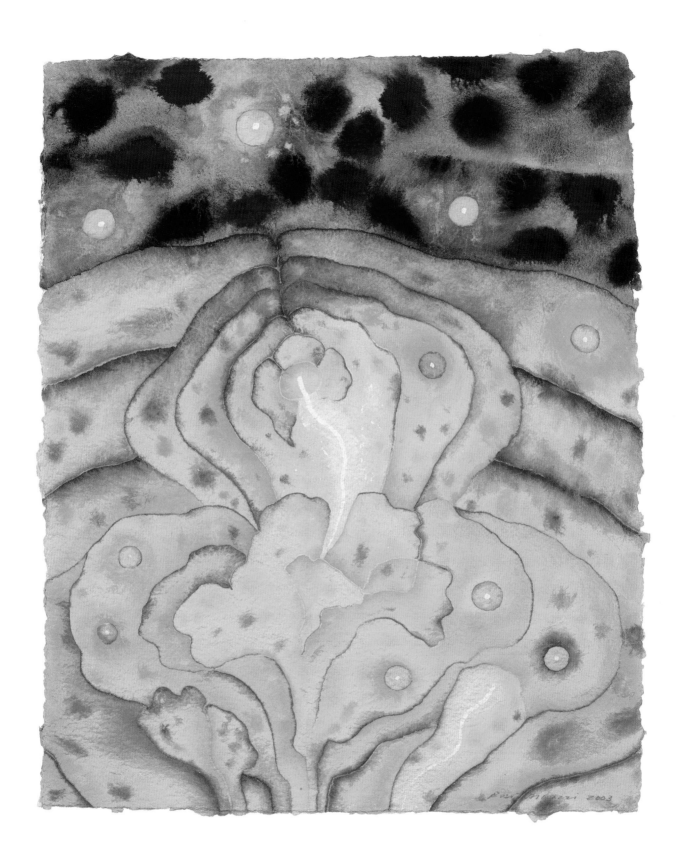

Twilight III

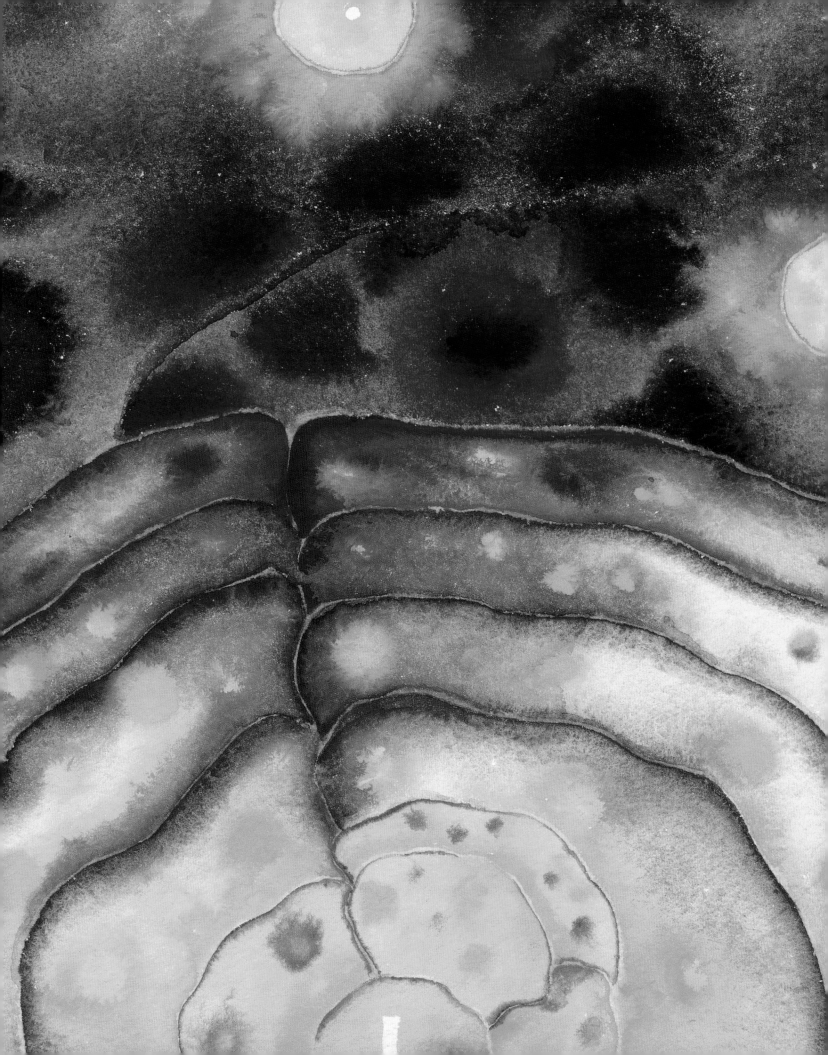

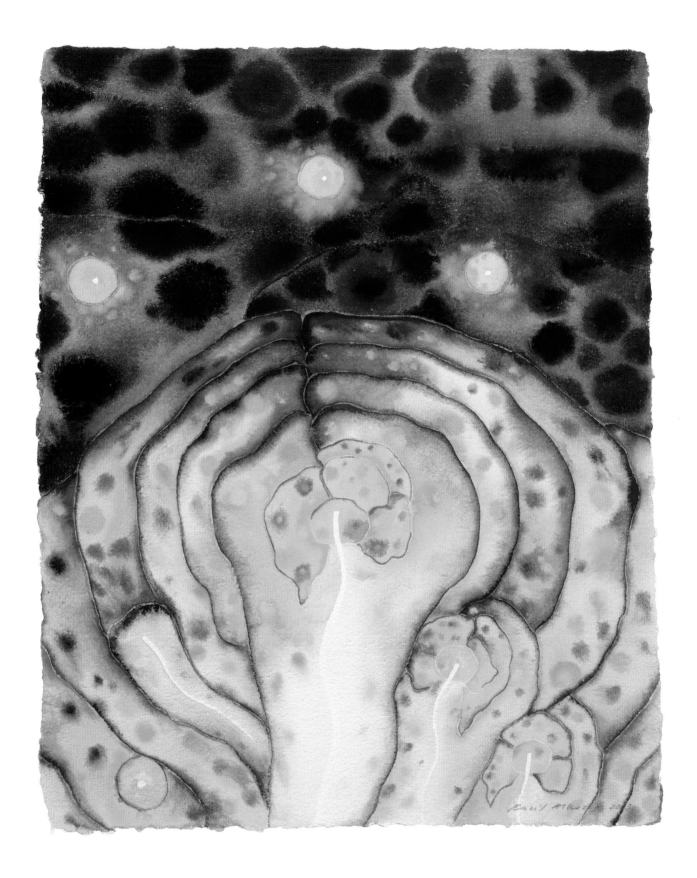

Twilight IV

2004

Having freed the self, one allows the unconscious to flow, cajoling the higher conscious to emerge, which then becomes basic and singular in that it is being manifest from an individual entity, Universal also because the theme, which is the Soul, is so, and jointly then, it can be called a Spiritual embrace. One is taken, the mind is taken, the Spirit-force is taken, once more to a realm beyond, on its very many latitudes. An inner space mirroring the outer one; reflecting the outer one within the Soul of an Earth body, but where the mind finds release, drifts out as in a dream, and where the dreams are no more than moments of startling truth. These are deeply experienced and refined metaphysical growths that find expression not so easily in words, but more so in images, transposing the translucent forms, witnessed and experienced, with paint on canvas or paper.

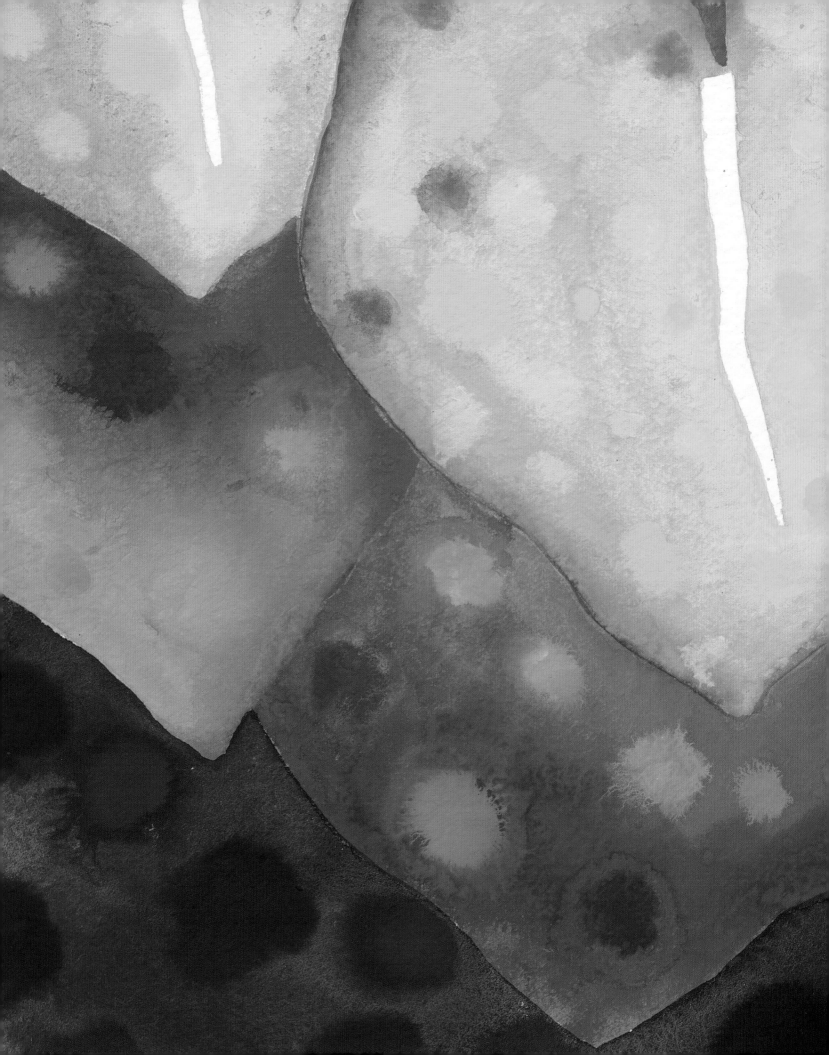

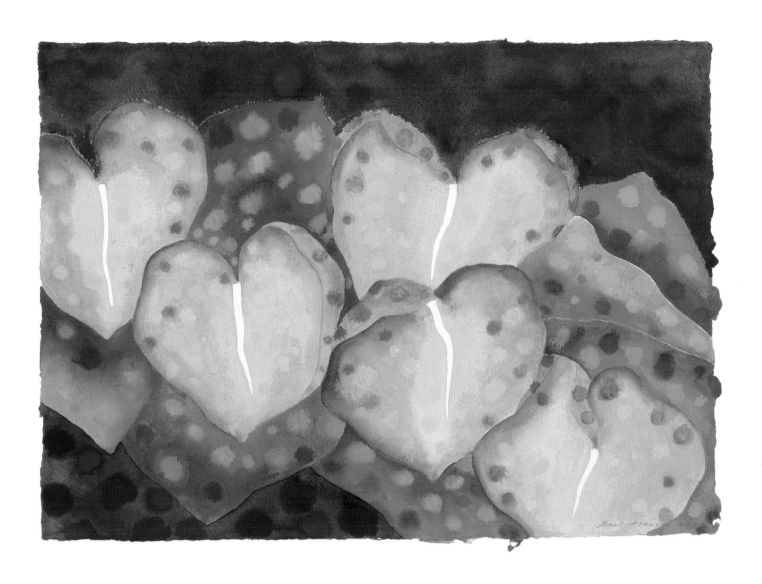

Anthurium I

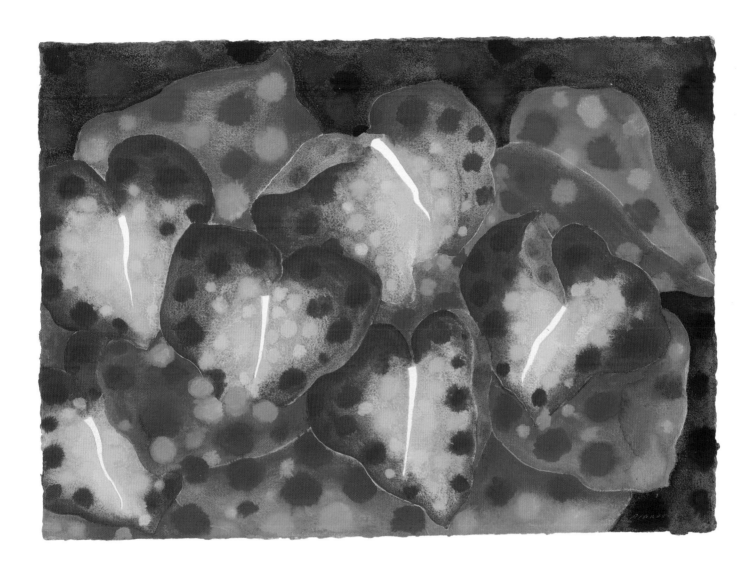

Anthurium II

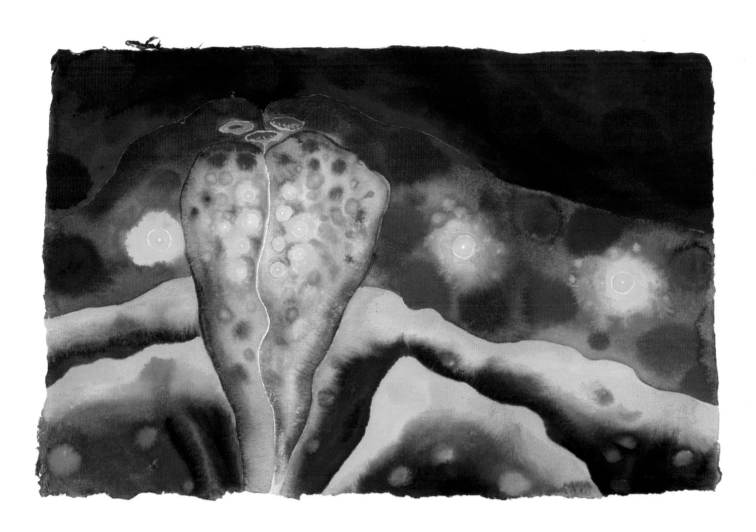

Blossoming Spring X

2005

A perfection of Spirituality is sought by the image of the Seal, the image of the Seal being the image of perfection of Spirituality; where the spirit body with all the knowledge, love, and faith of this plane lives in total and perfect harmony with the Universal, Spiritual entity of timeless moments, with all the knowledge, wisdom, love, and faith of that plane.

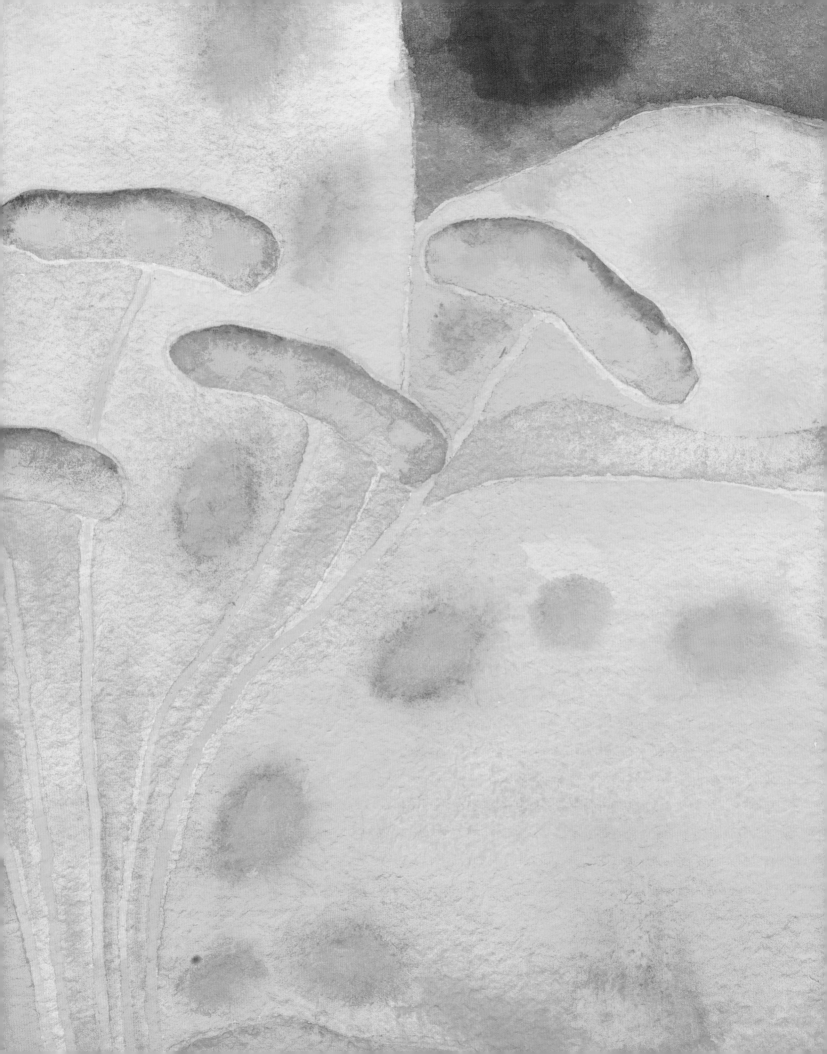

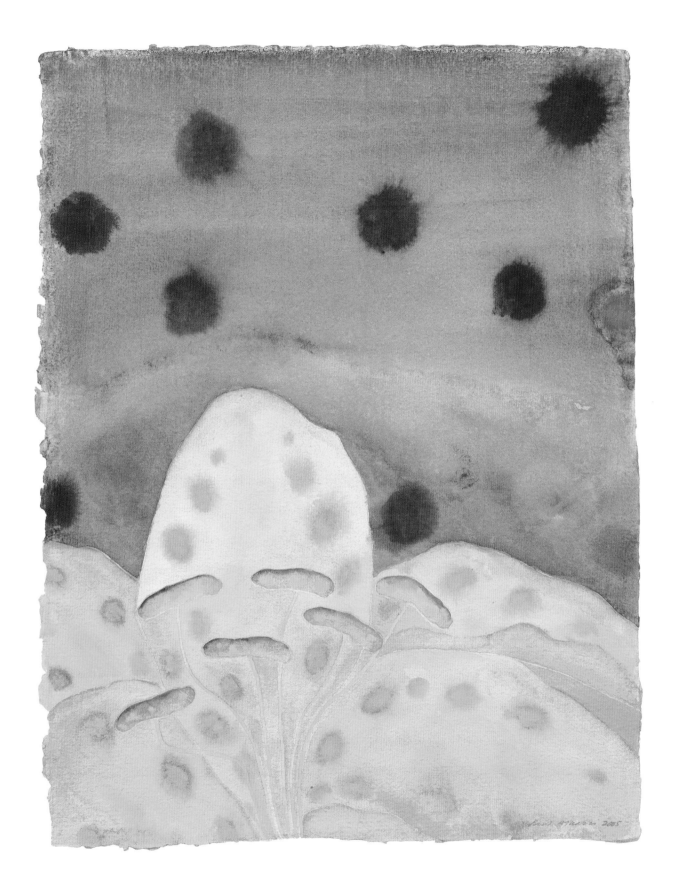

Summer Lilies VI

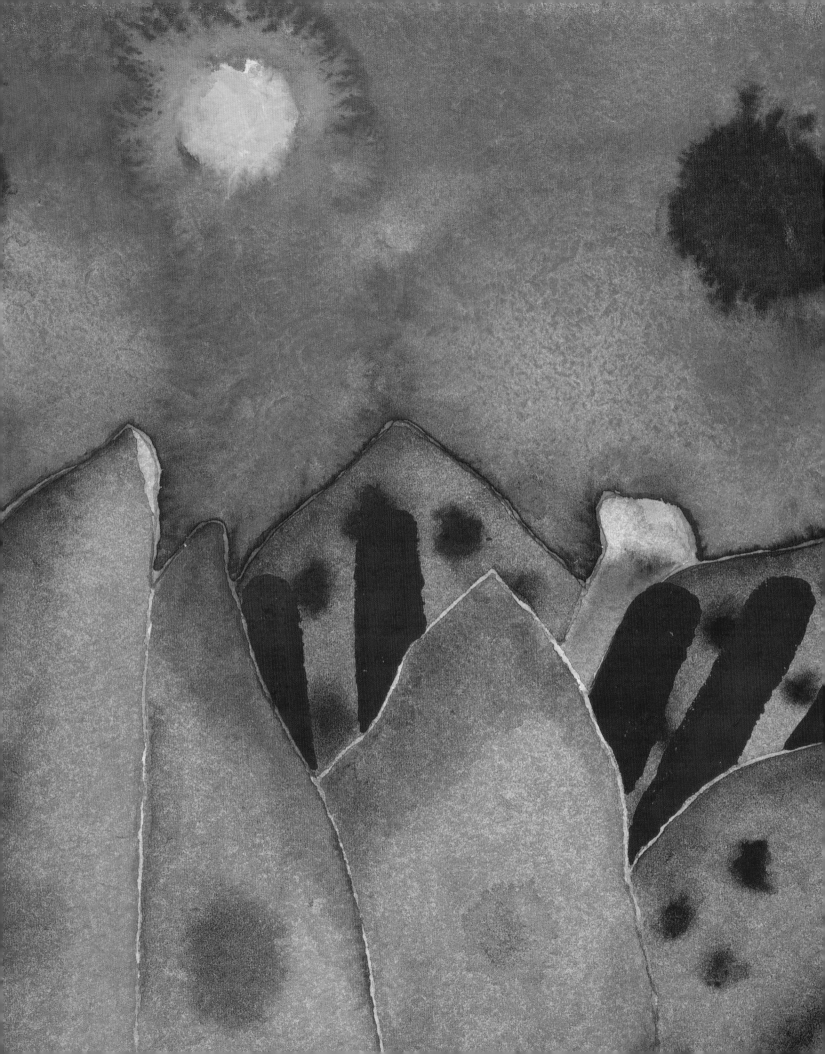

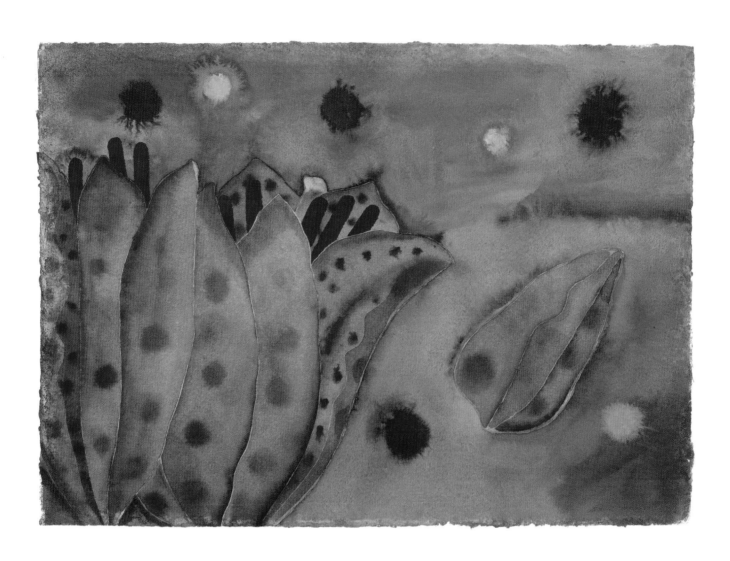

Summer Lilies VII

2006

A painter expresses himself with images, just as a writer does with words, but a writer is never then asked to paint an image to express better what he has written. Why then is a painter asked to express in words what he has painted? If words are required to express a painting, then either the artist has failed to express himself, or the viewer has failed to be empathic, by not allowing the images to penetrate that region of thought and feeling where words are not needed.

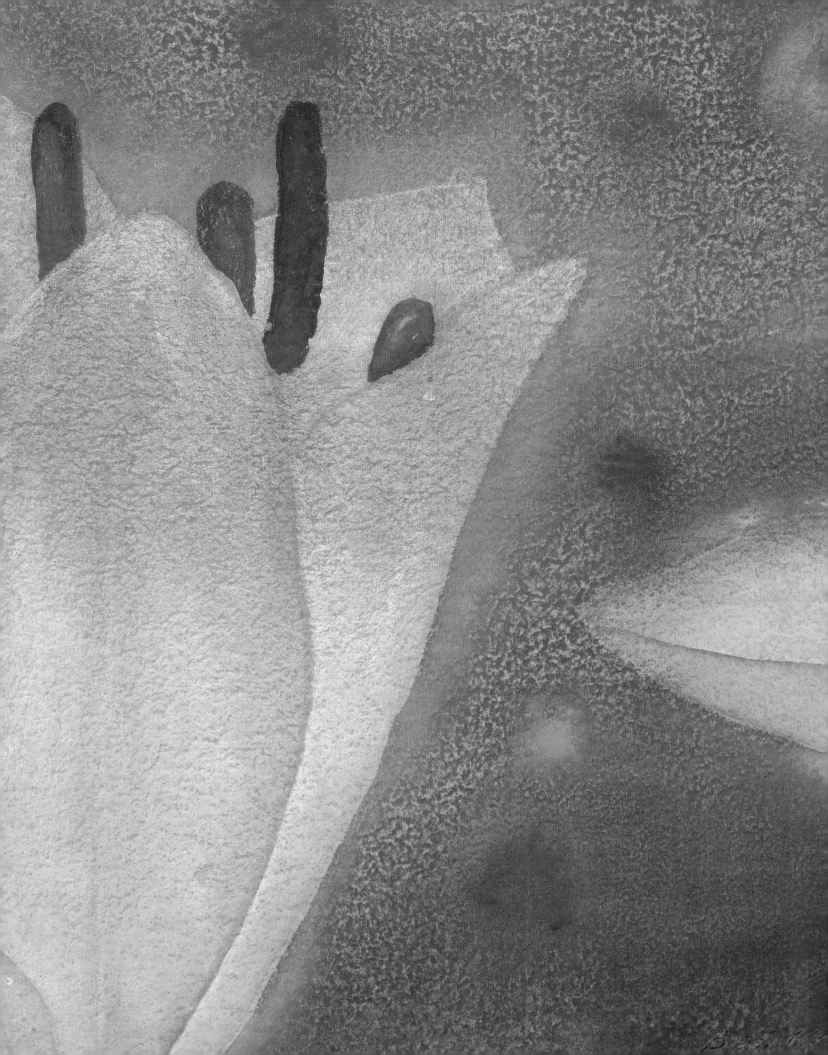

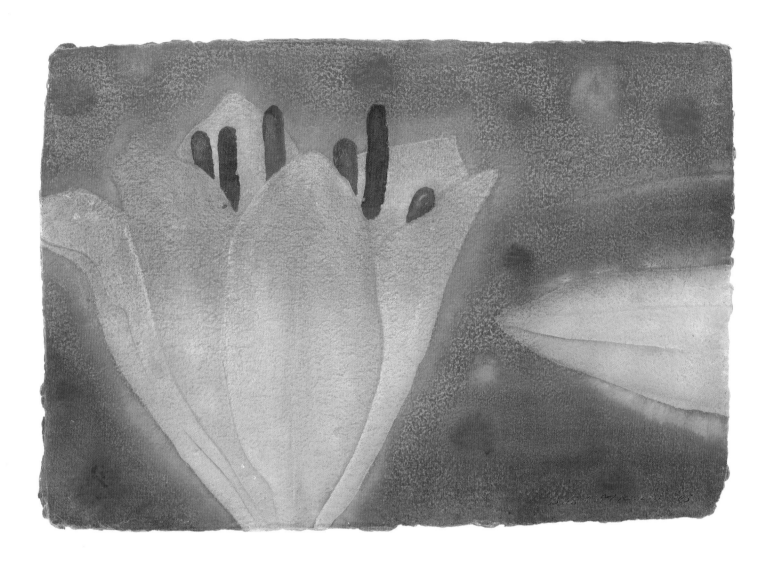

Dream Lilies

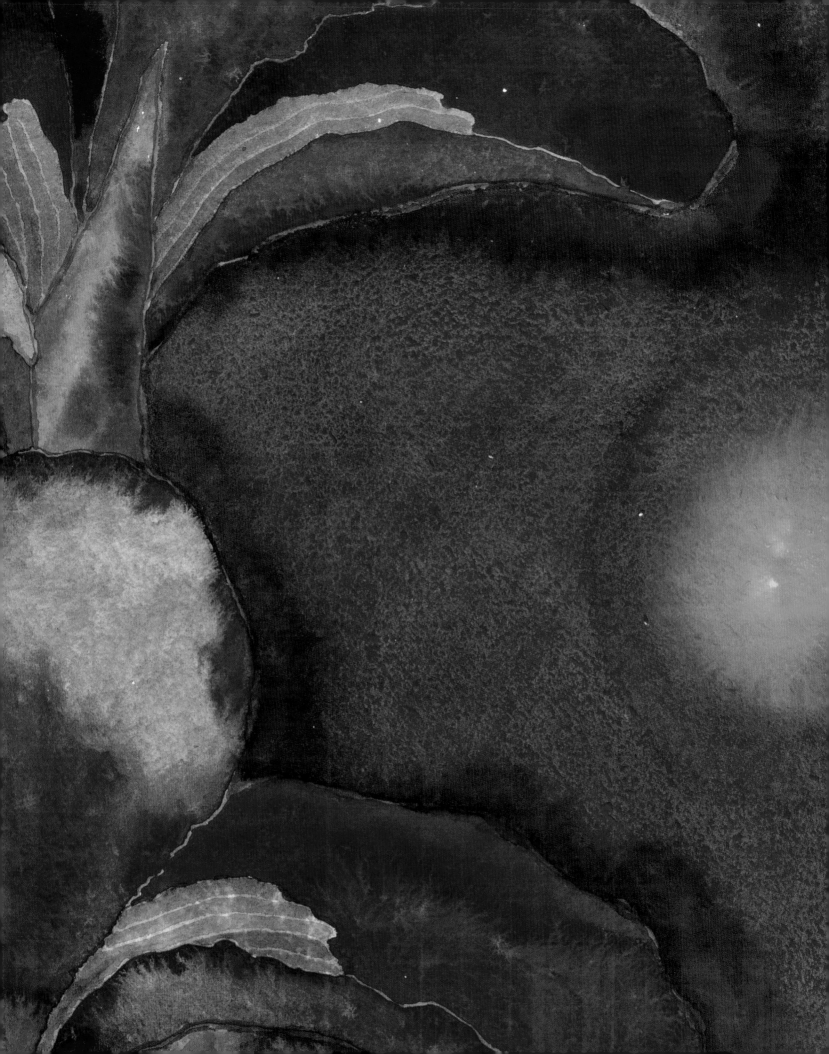

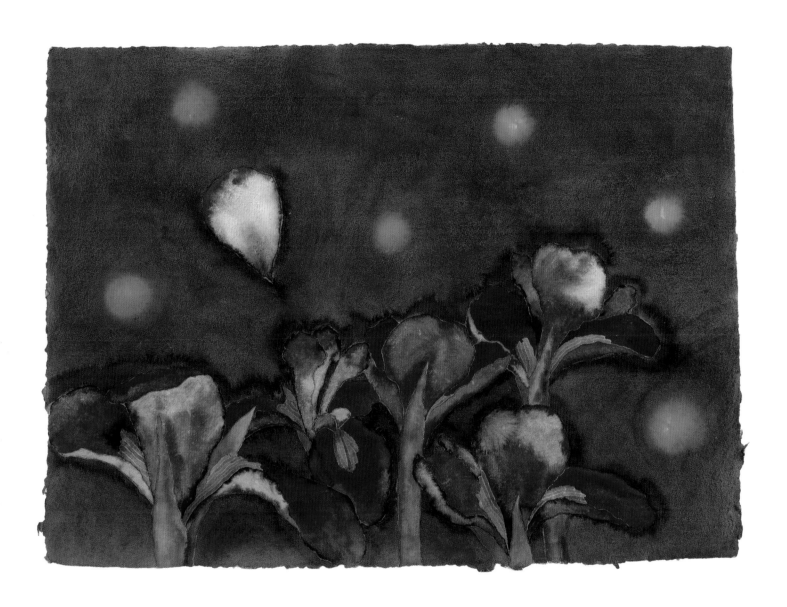

Iris and the Grasshopper that Flew Away

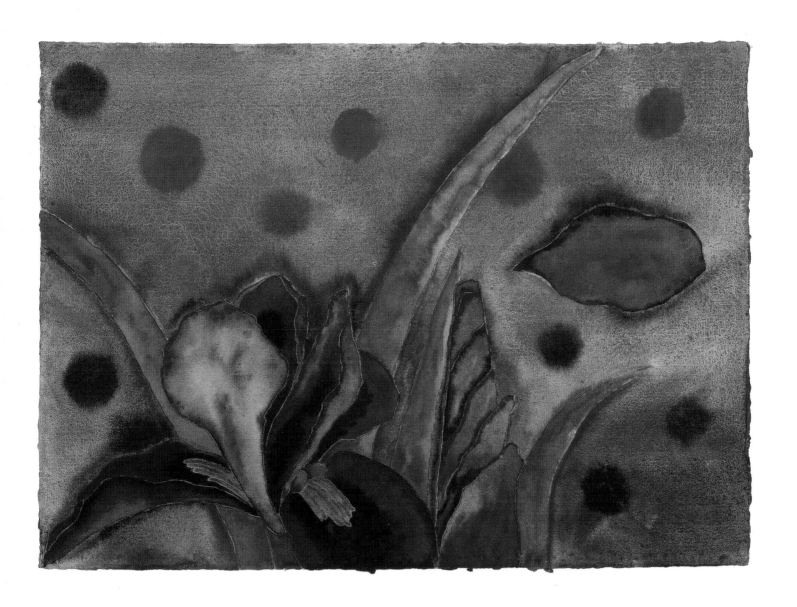

Iris at Dusk II

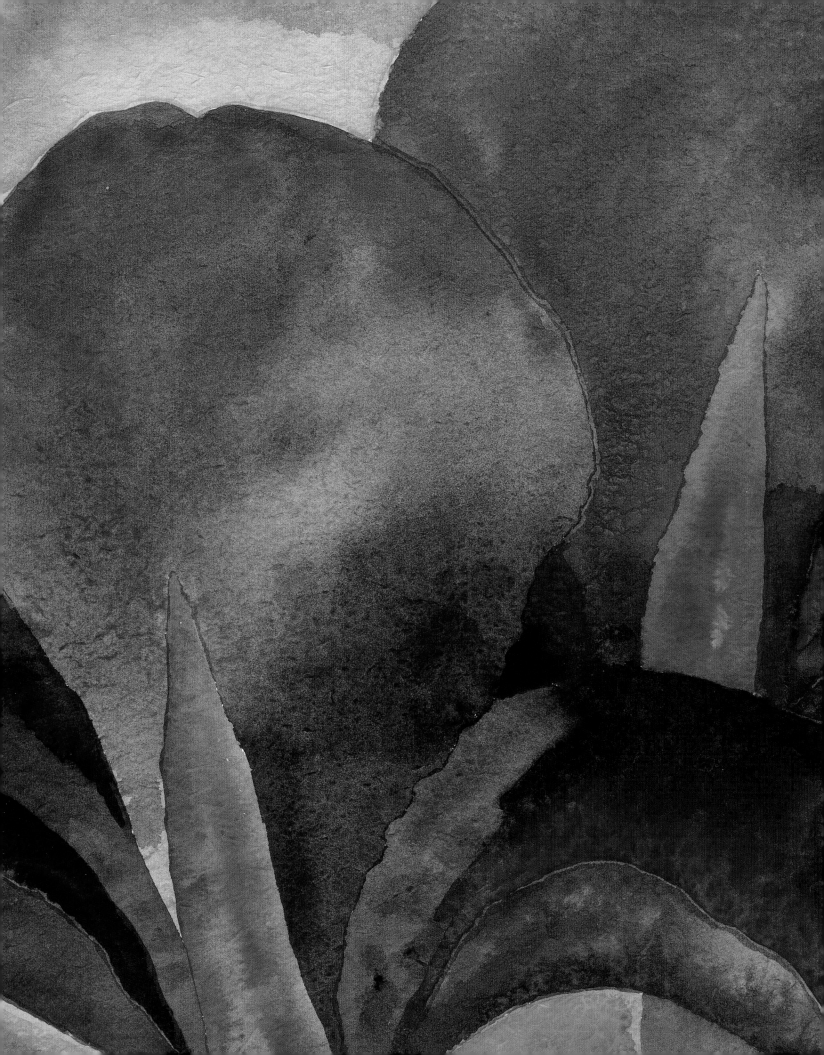

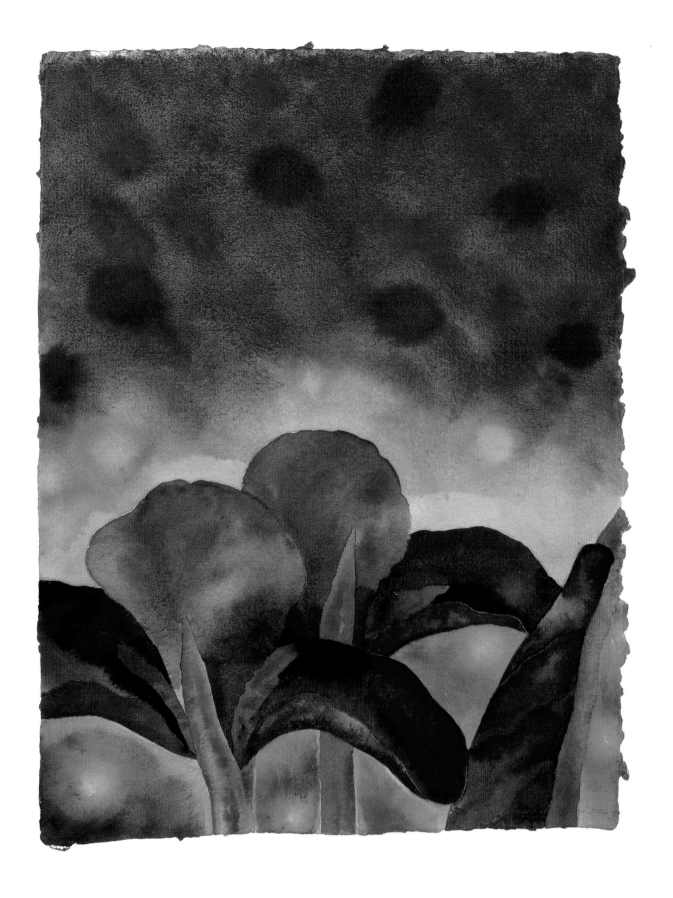

Iris at Sunset

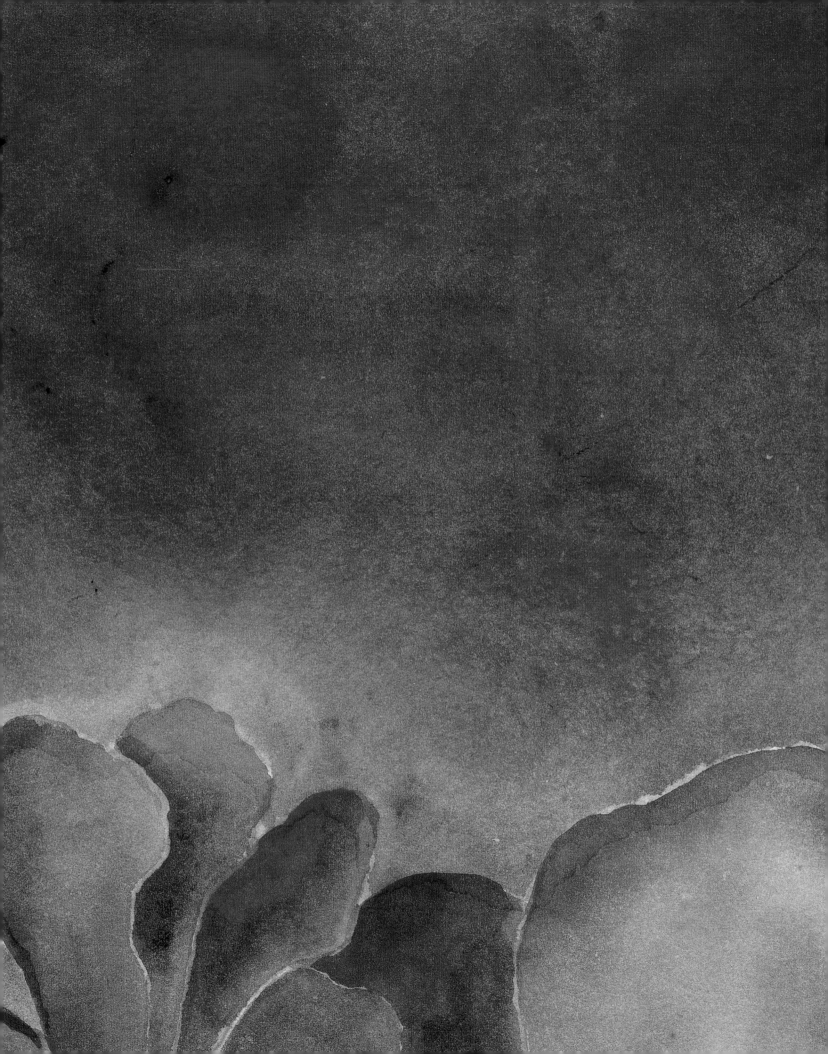

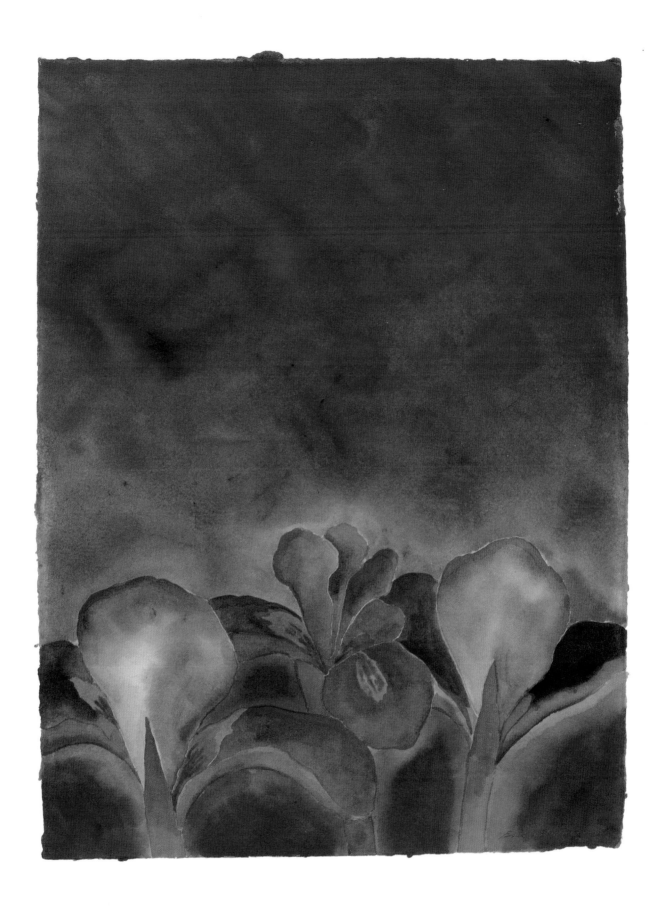

Iris Before the Storm II

2007

An artist, with all his complexities, paints for himself and not for others. An artist reveals himself, his thoughts, his feelings, by his work, to himself, and for himself; and then others, perhaps, discover and see that self discovery, that self revelation, in matter.

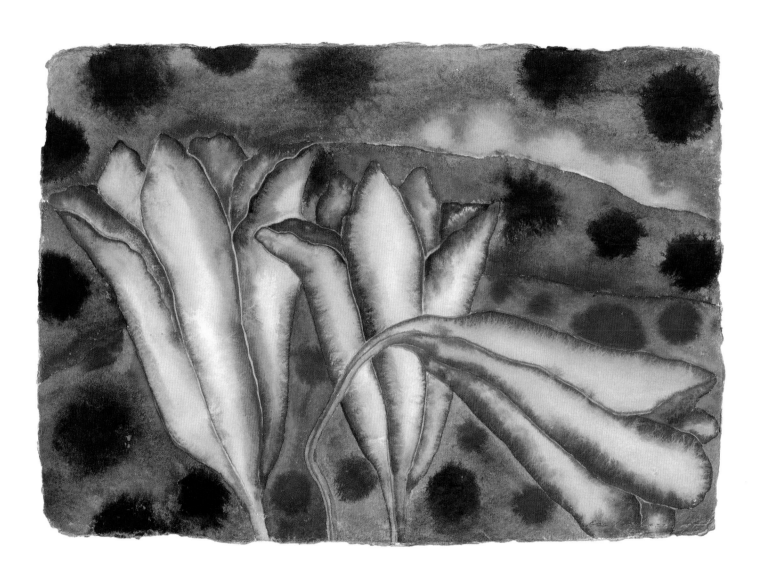

Ode at Twilight VI

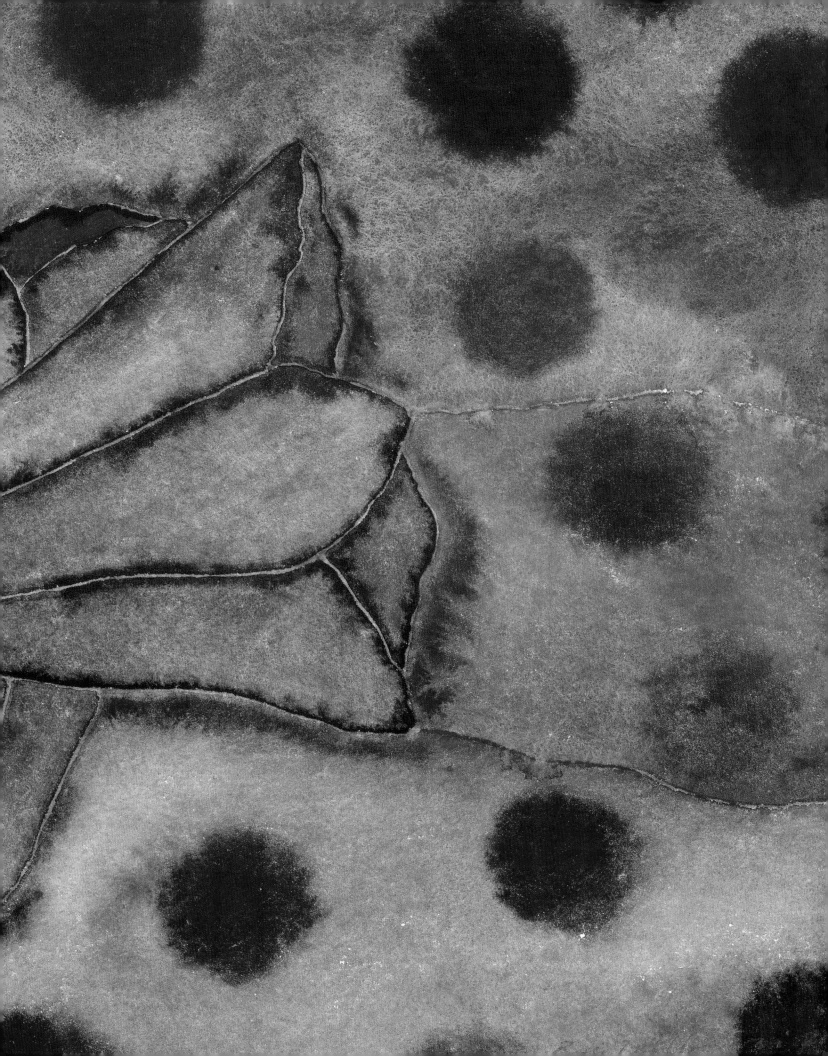

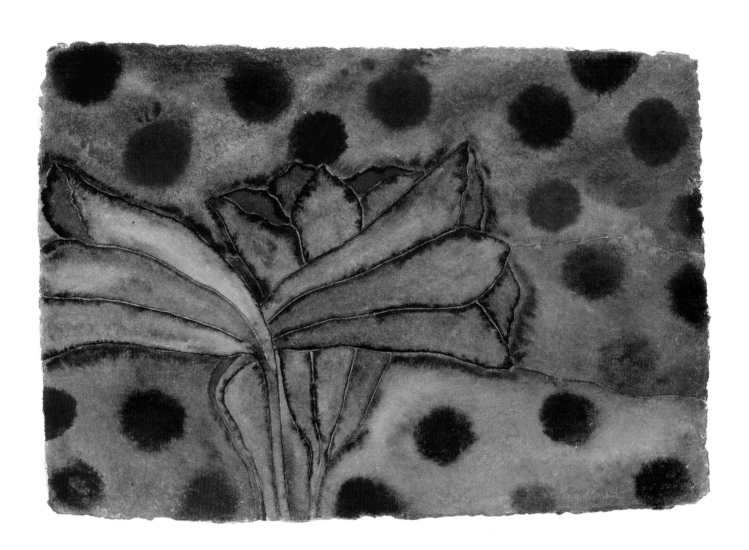

Ode at Twilight VII

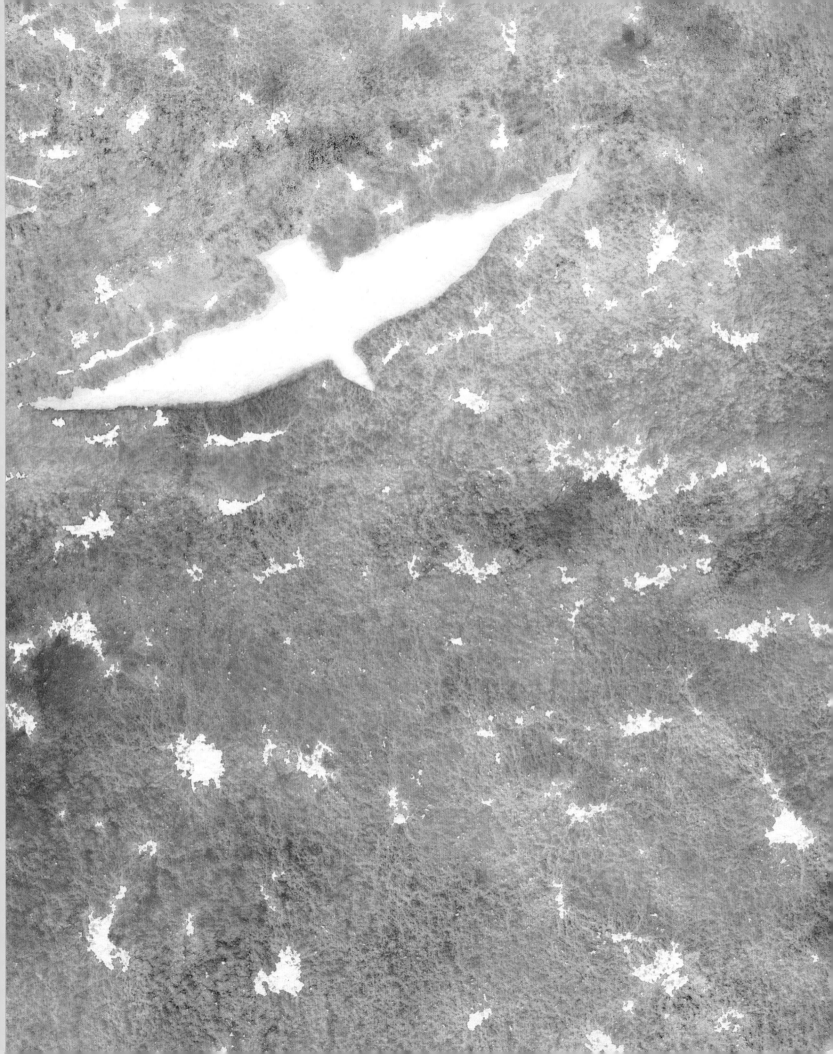

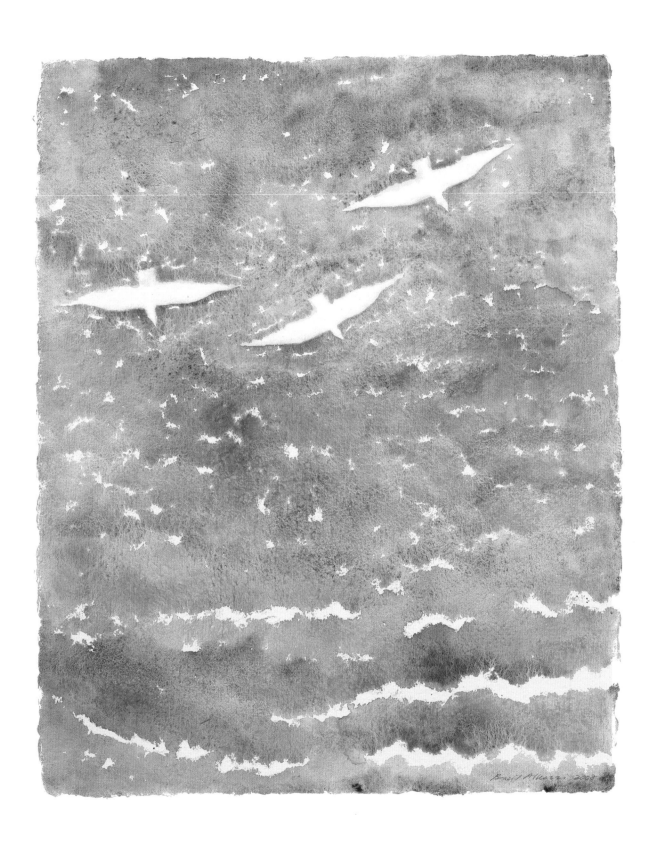

Dream Odyssey Revisited II

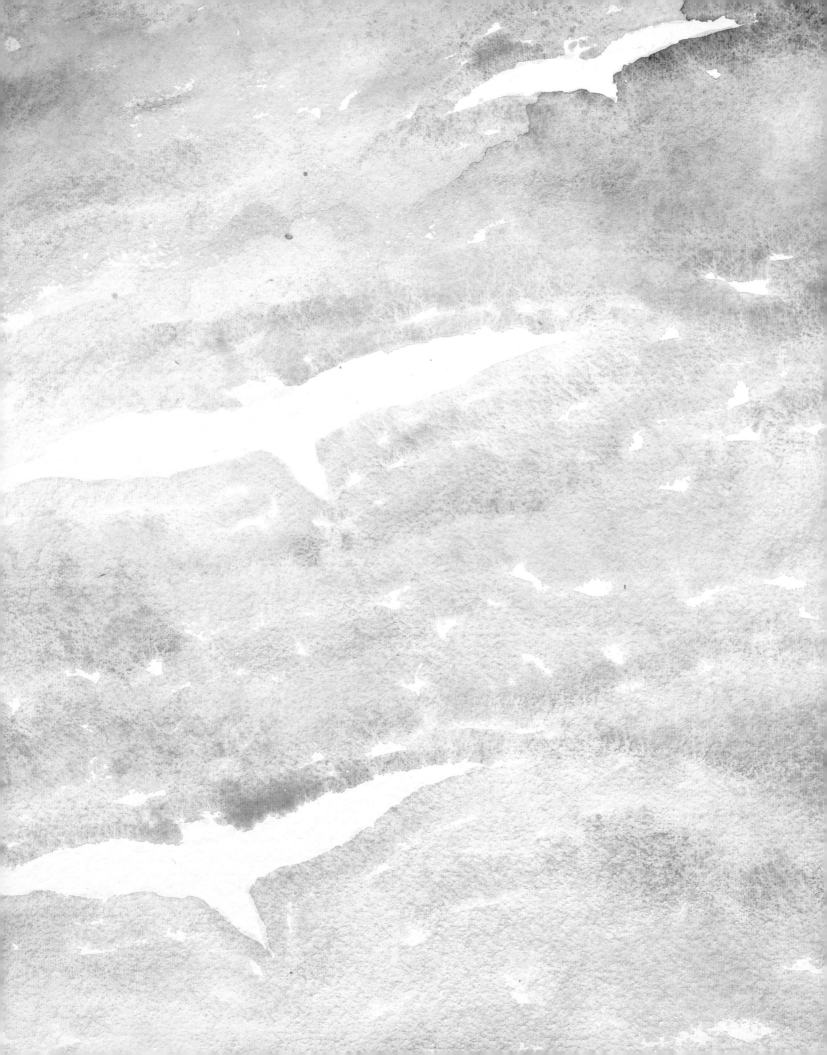

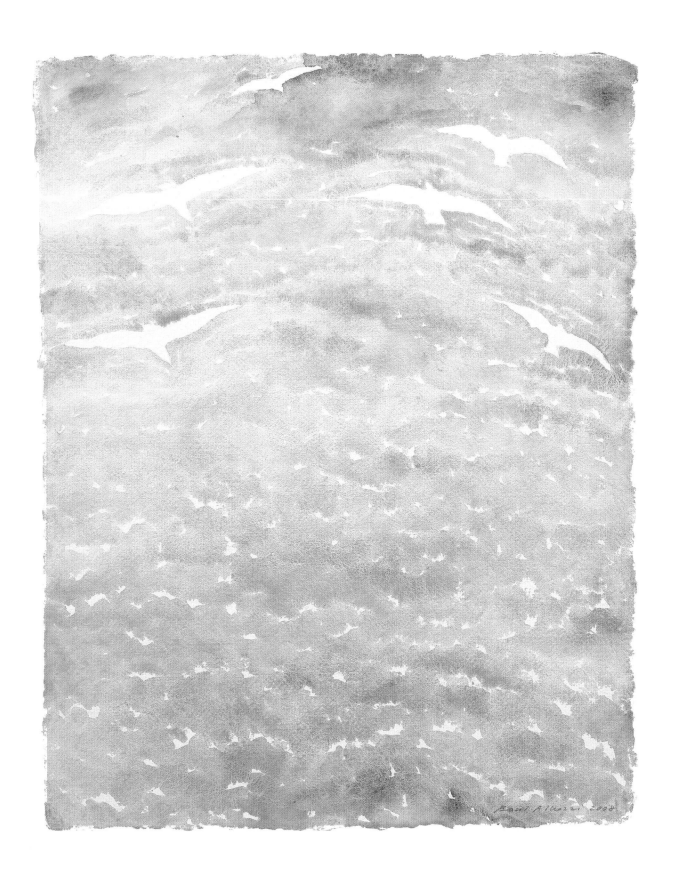

Dream Odyssey Revisited III

2009

There comes a time in many, when there is that curious feeling that there is something within one germinating, waiting to be born. But one must wait for the new dream to take form, after all a change of direction is not defeat, a change of direction is also an evolvement, an ascension, and with each change, one must grasp that moment...

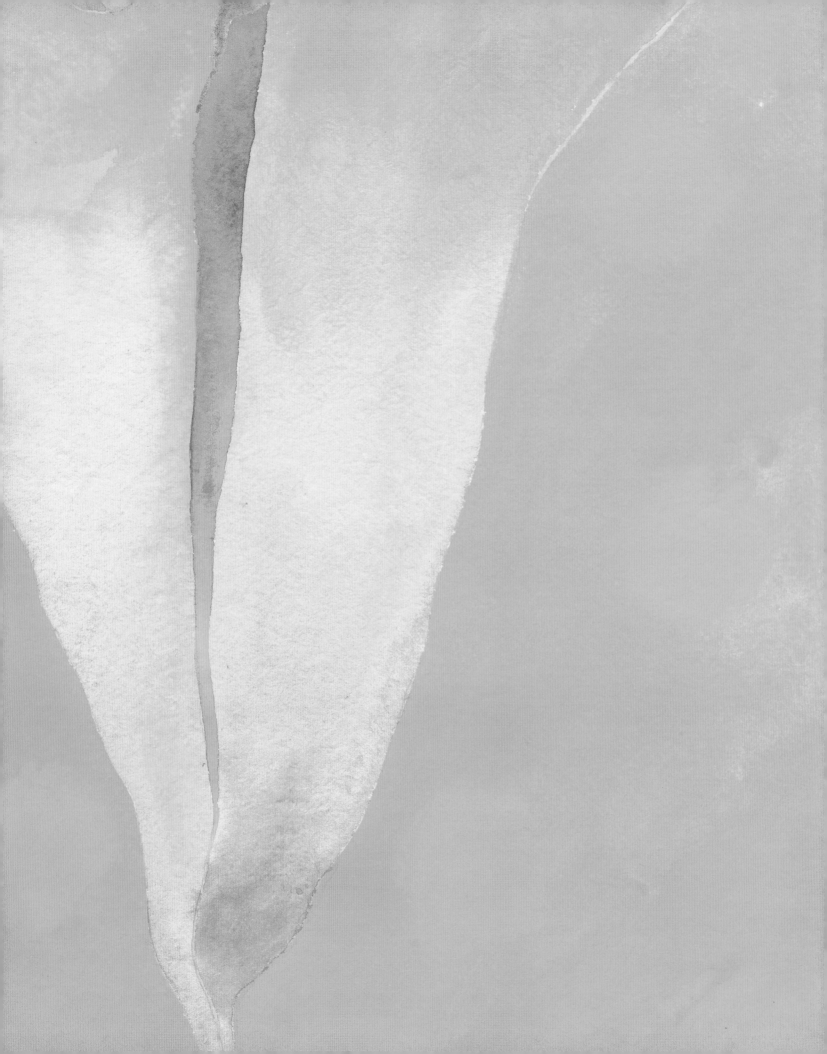

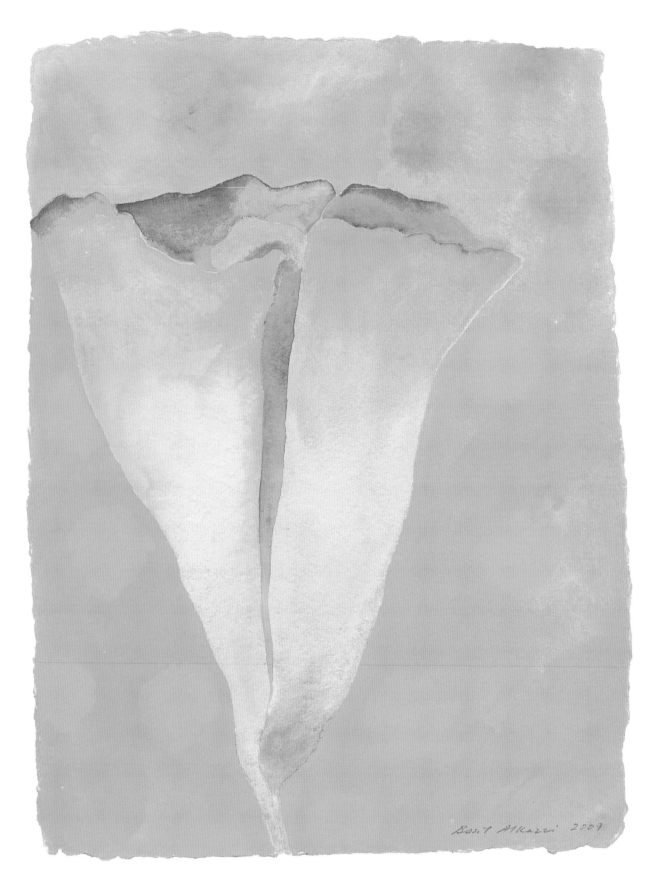

Ascension III

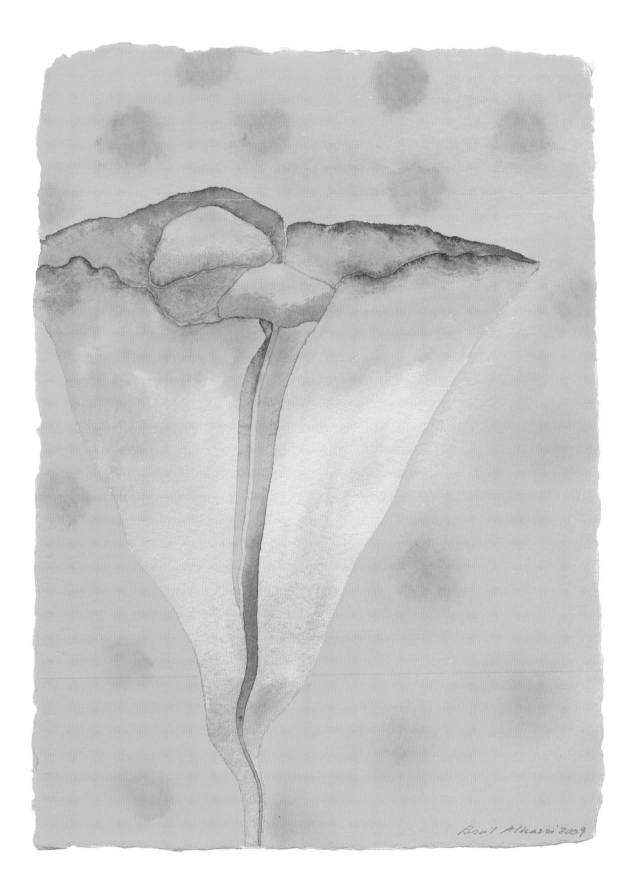

Ascension IV

2010

This is after all not a journey from this world that we make into the other; that would be far too grandiose; but a journey from the other one, that we make into this one. It is a learning journey, a giving and loving journey, a journey of and for compassion, in order to fulfil and enlarge the experience of the life force on the other side, on one's return; to complete the journey in harmony with the inner self.

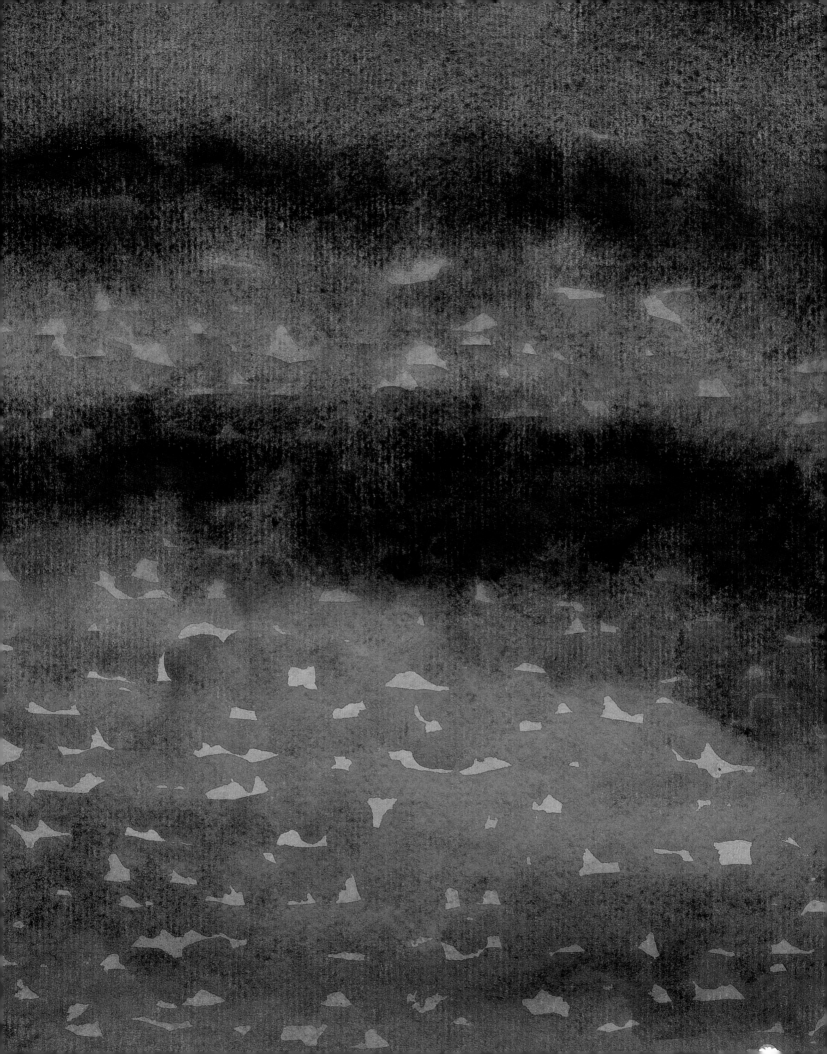

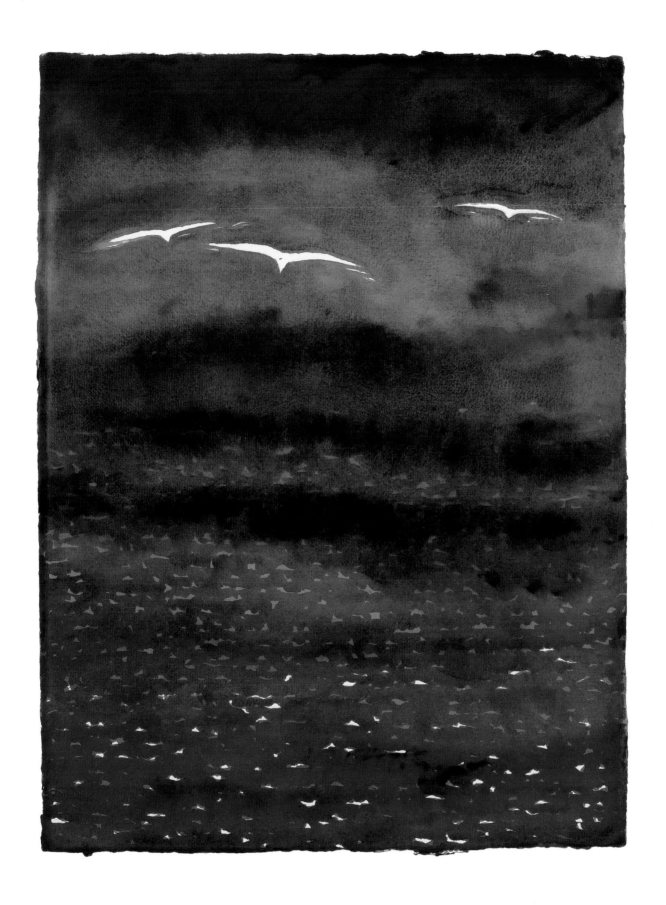

And Still You Whisper, Still I Wait, Yet Again III

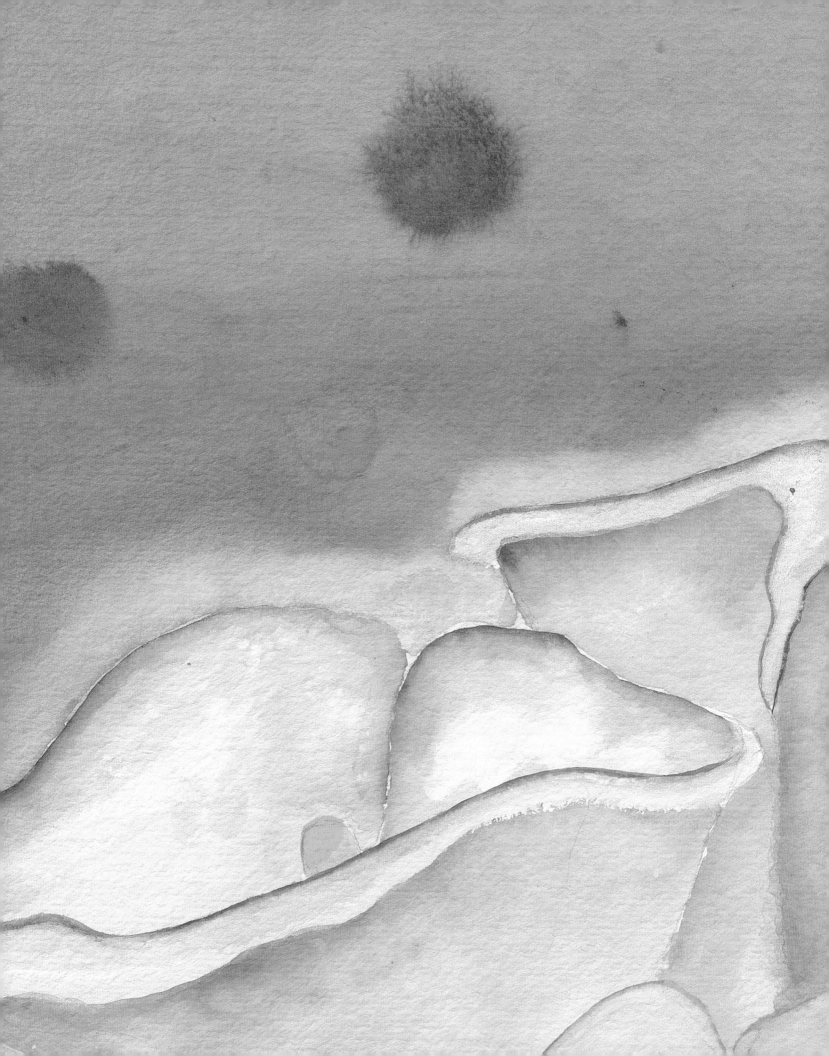

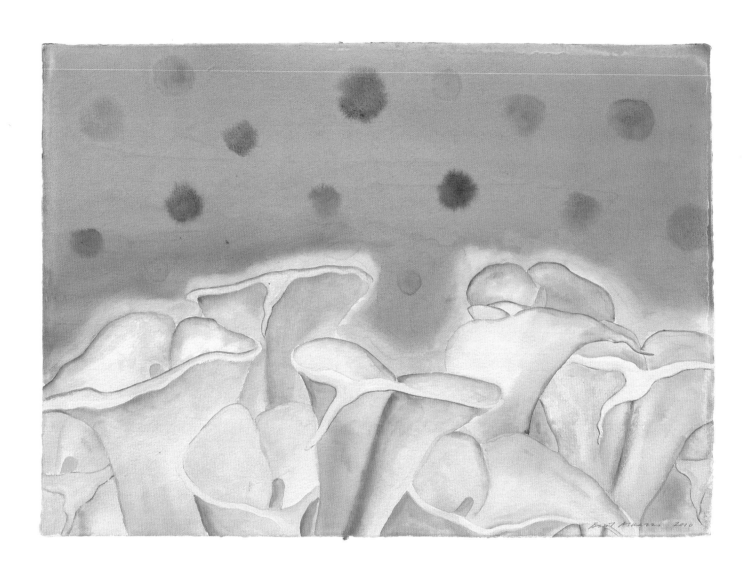

Ethereal Promises IV

2011

We look at a bird soaring in the sky with deep longing, for it epitomises the Soul, free, unbound by Earth, a Soul before birth. That image of the soaring bird is a memory of one's Soul, before the birth on Earth.

It is a memory, we, each, must return to...

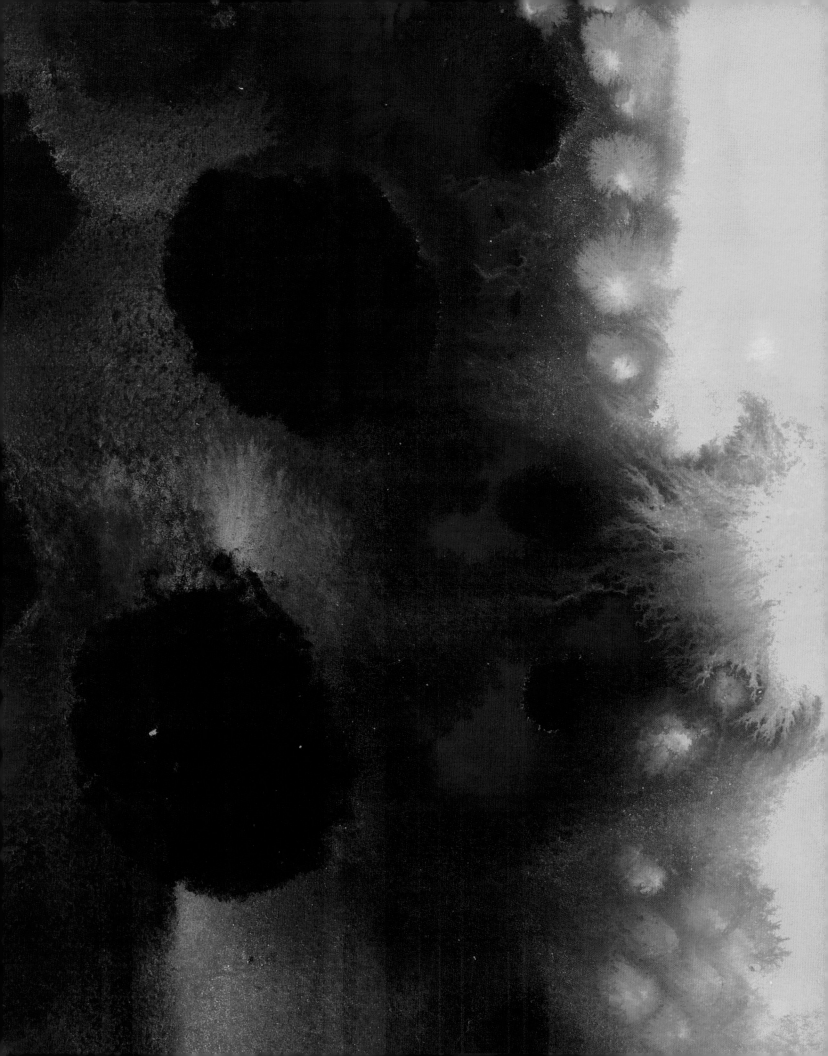

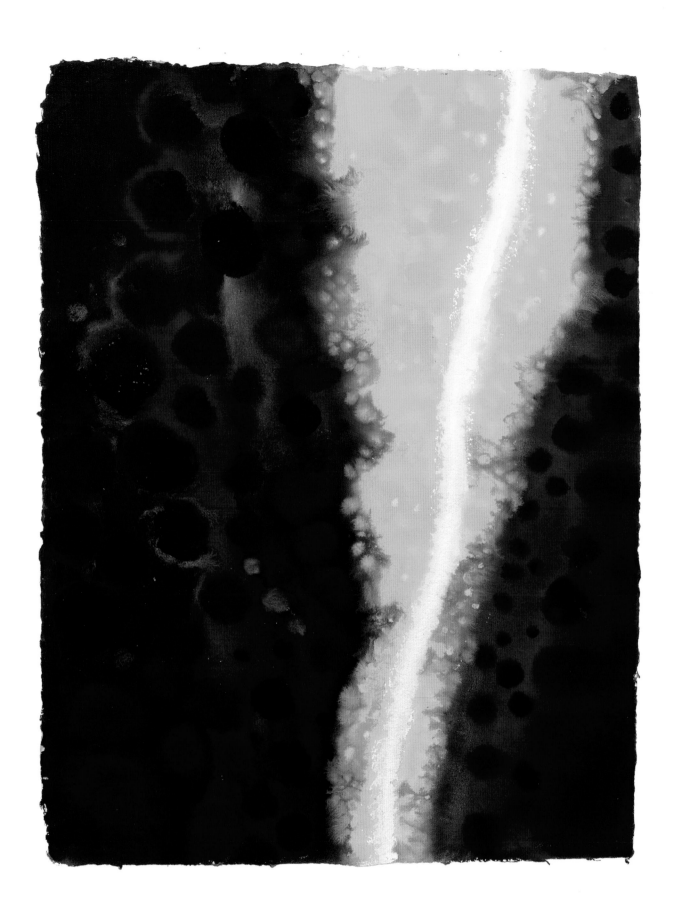

Ascending Angel Revisited III

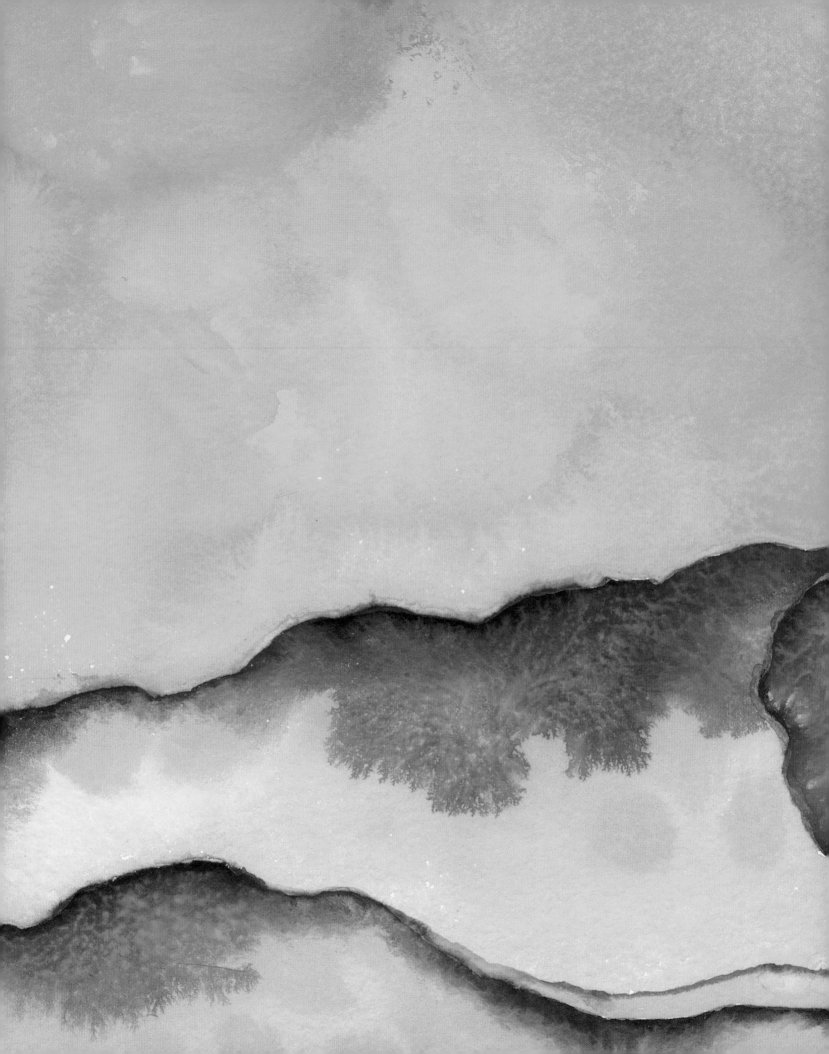

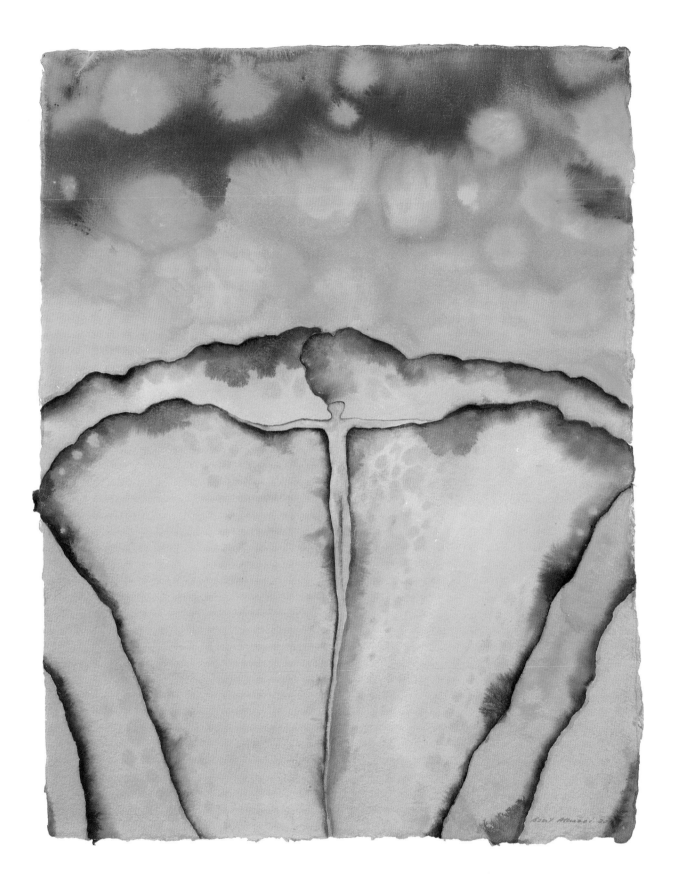

Ascension in Beatitude II

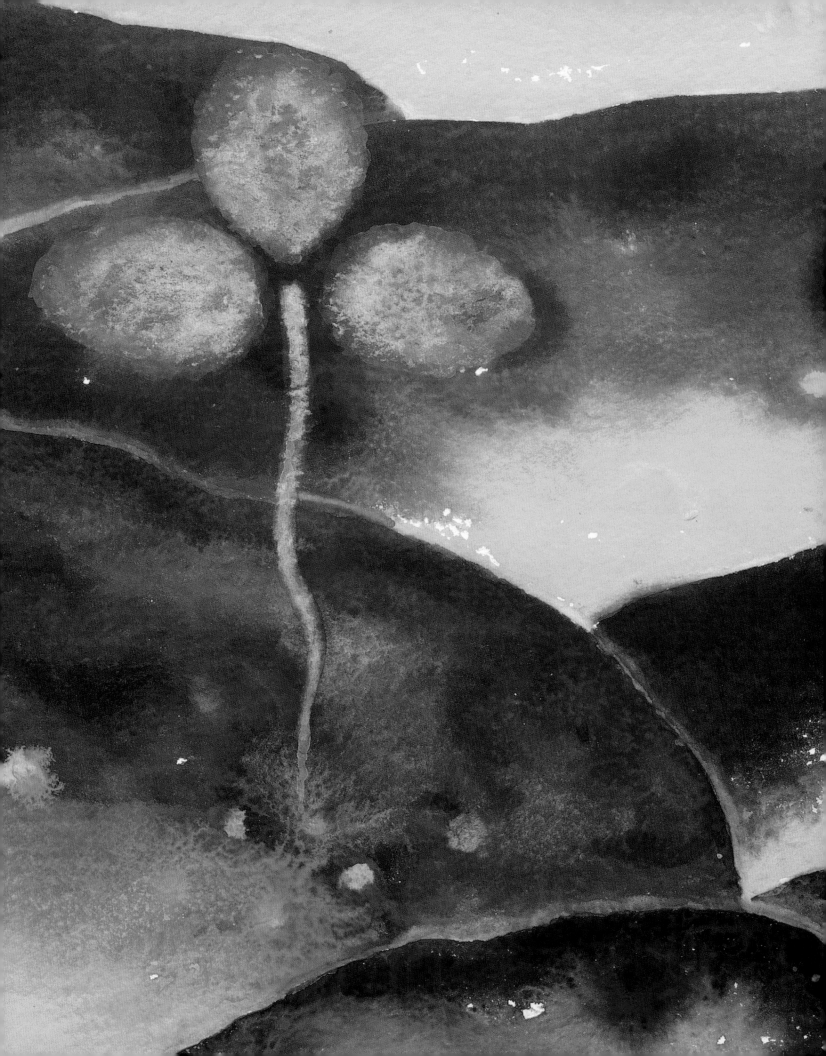

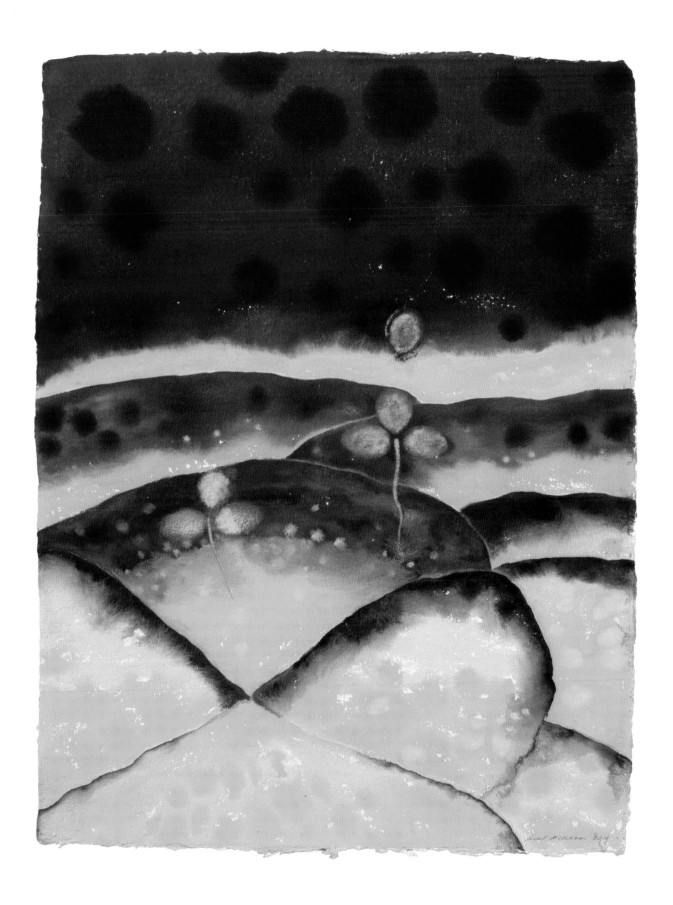

Twilight of Whispering Dreams II

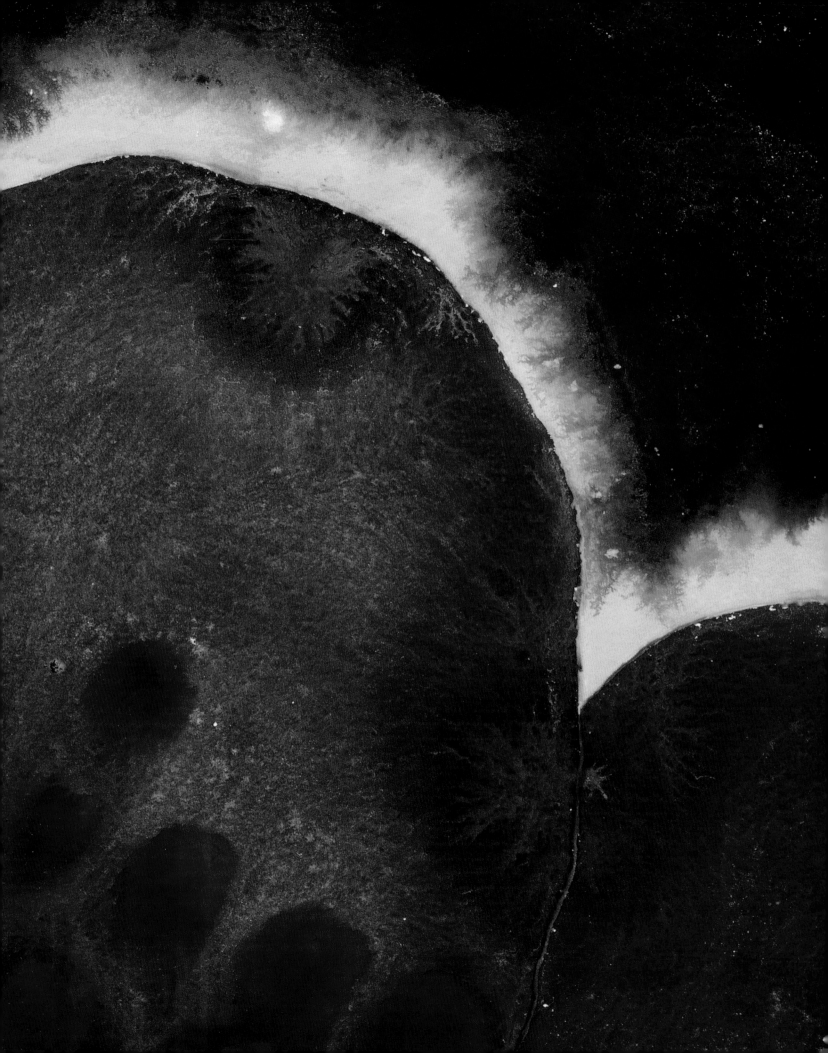

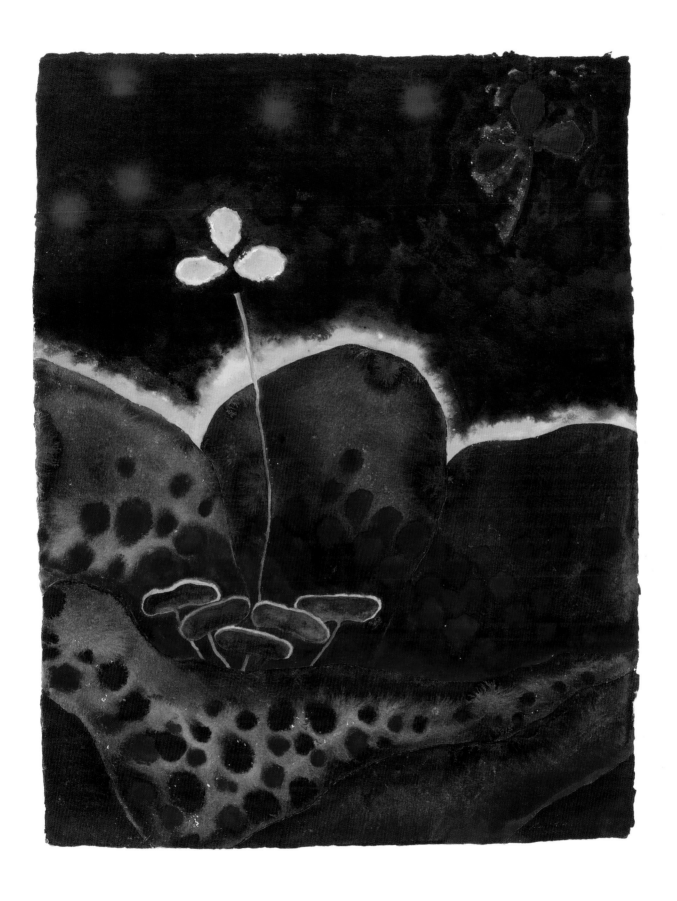

Twilight of Whispering Dreams VI

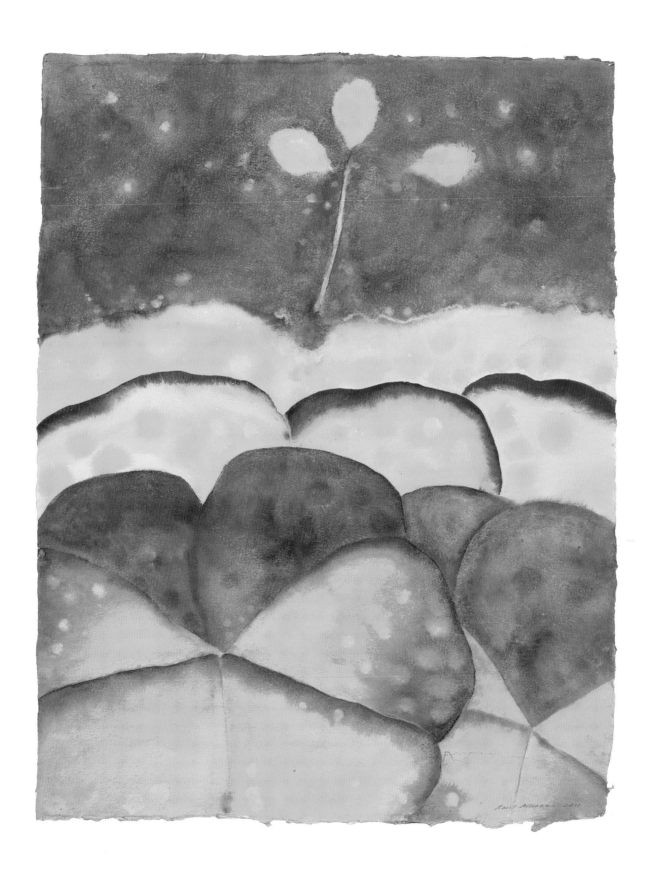

Whispering Dreams at Sunset

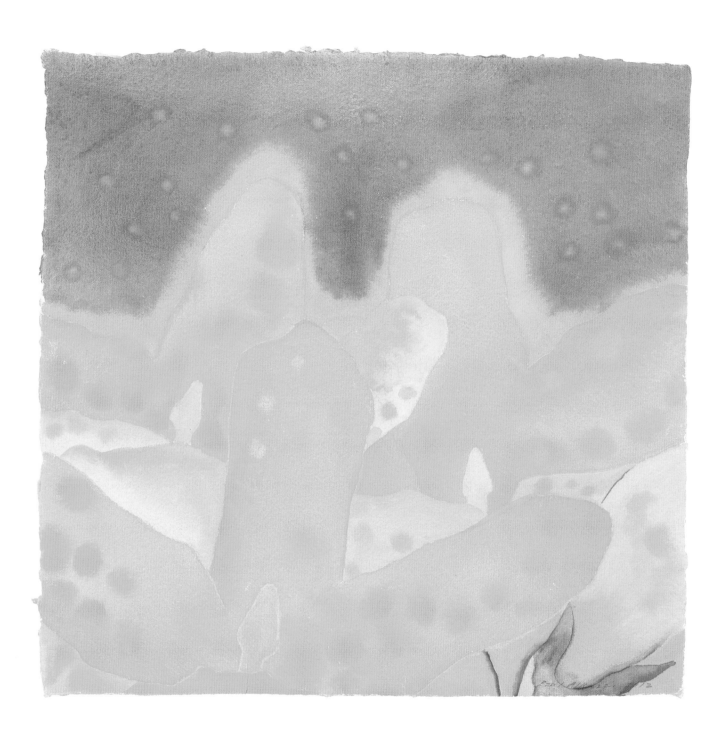

Beatitude in Anticipation

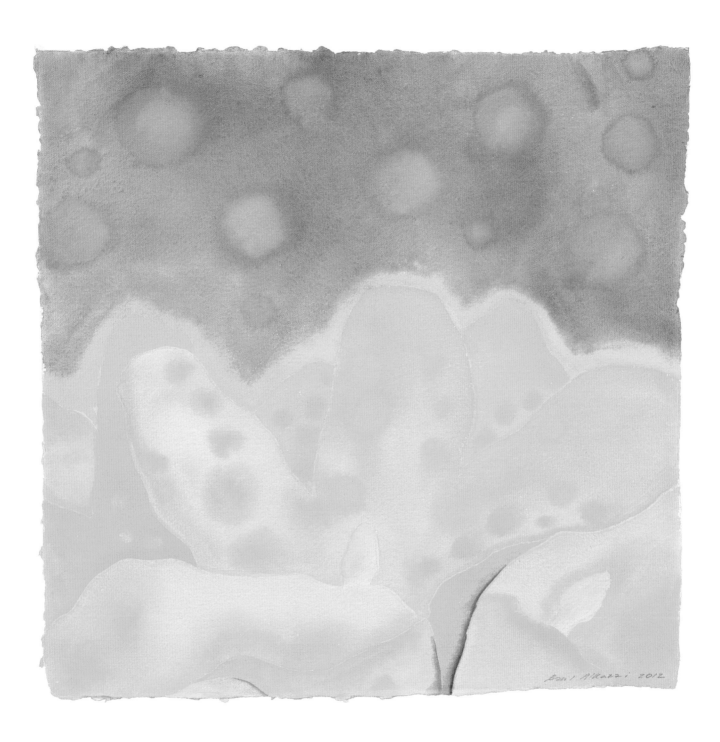

Beatitude in Anticipation IV

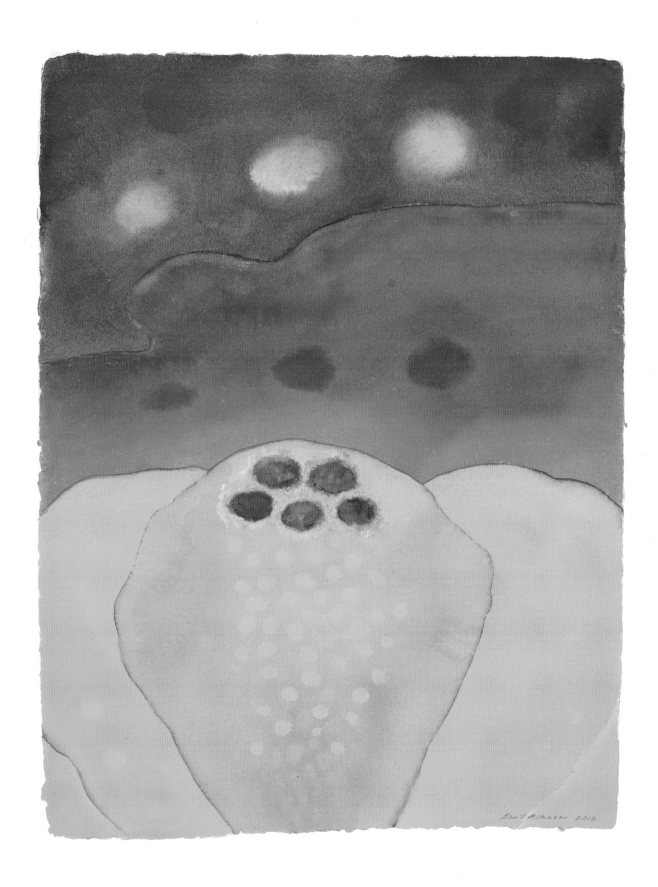

Whispering Dreams at Dawn

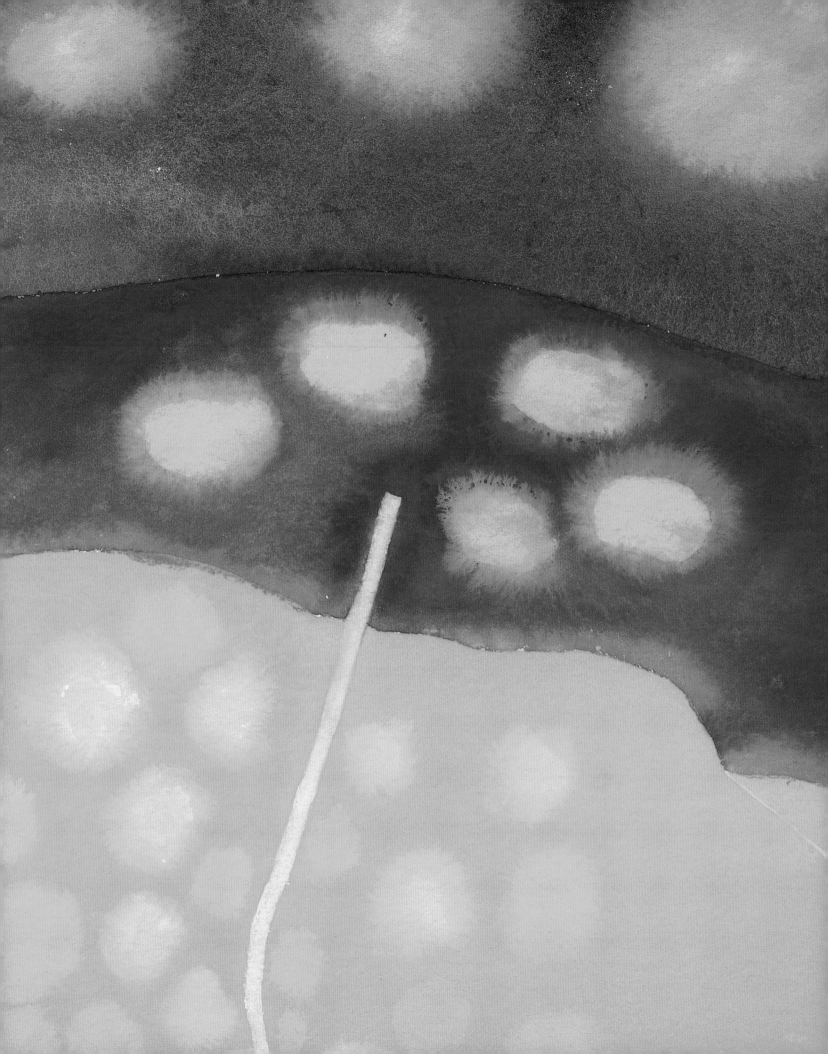

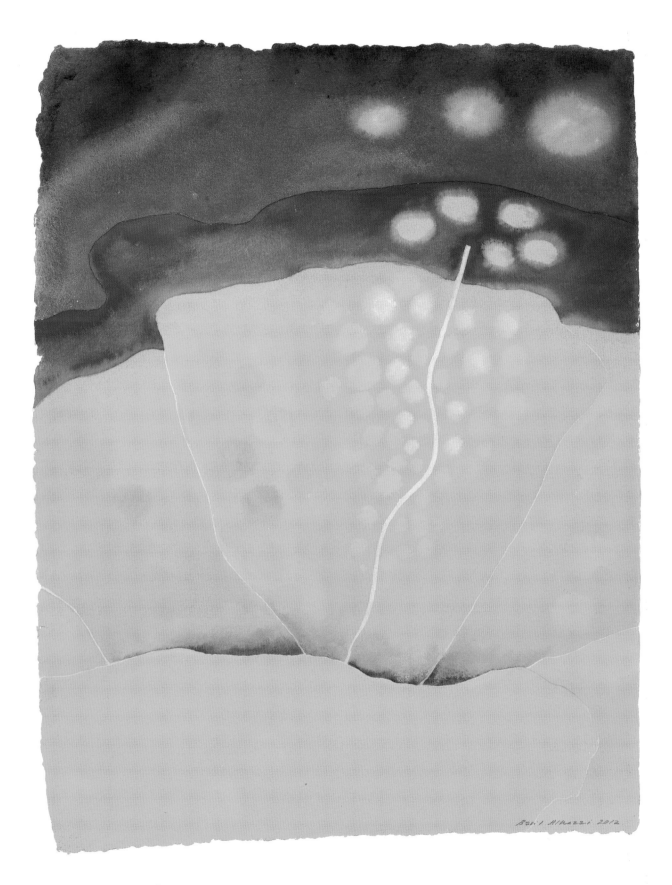

Whispering Dreams at Dawn III

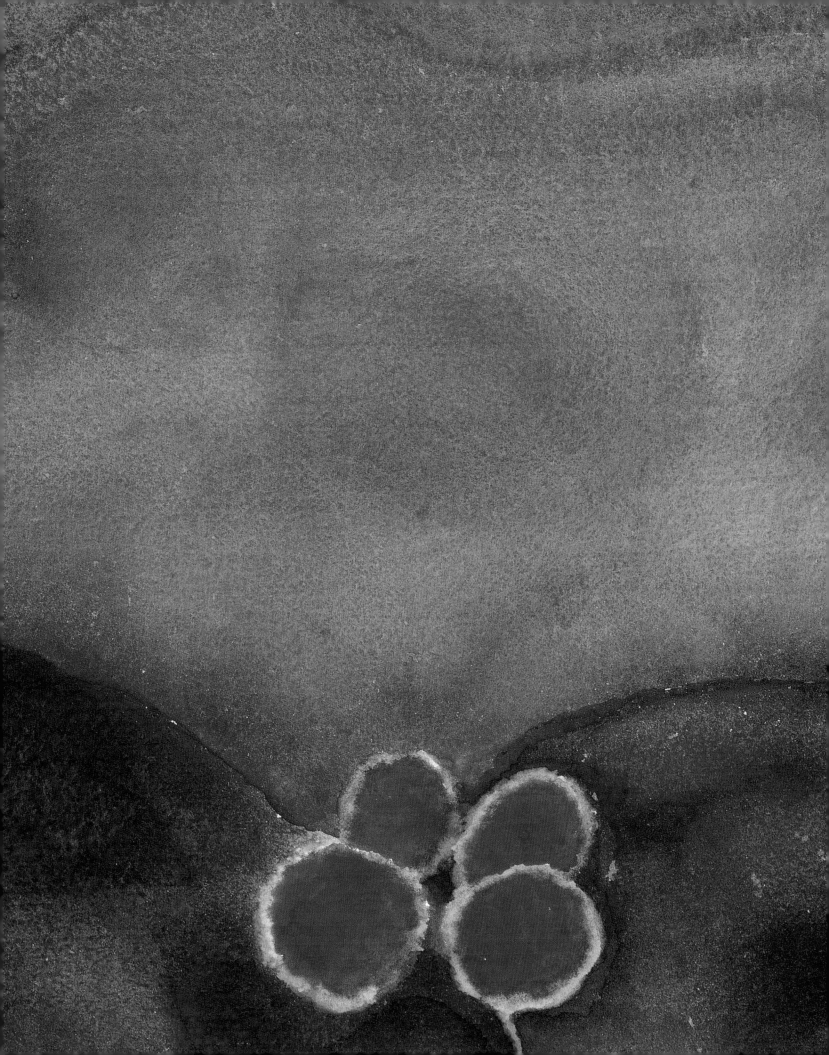

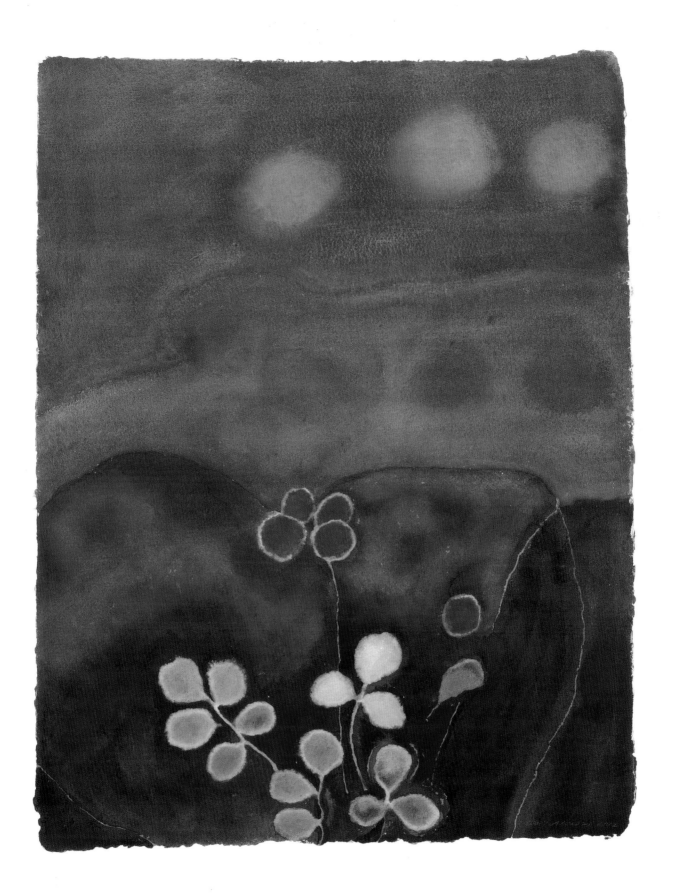

Whispering Dreams at Nightfall

List of Works

All works are gouache on hand-made paper.

2003

Blossoming Spring III
50 x 50 cm, 20 x 20 inches

Kiss of the Butterfly IV
77 x 58 cm, 31 x 23 inches

Kiss of the Butterfly V
77 x 57 cm, 31 x 23 inches

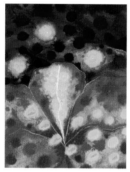

Kiss of the Butterfly VI
77 x 58 cm, 31 x 23 inches

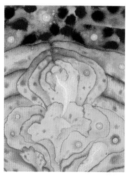

Twilight III
66 x 53 cm, 26 x 21 inches

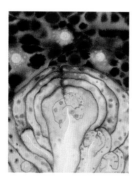

Twilight IV
66 x 53 cm, 26 x 21 inches

2004

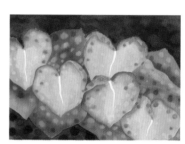

Anthurium I
56 x 76 cm, 23 x 30 inches

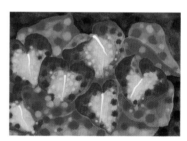

Anthurium II
56 x 76 cm, 23 x 30 inches

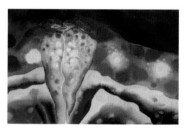

Blossoming Spring X
54 x 78 cm, 22 x 31 inches

2006

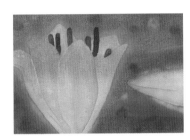

Dream Lilies
32 x 45 cm, 13 x 18 inches

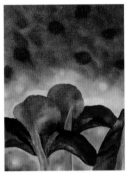

Iris at Sunset
77 x 57 cm, 31 x 23 inches

2005

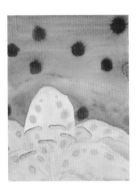

Summer Lilies VI
77 x 57 cm, 31 x 23 inches

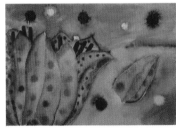

Summer Lilies VII
57 x 76 cm, 23 x 30 inches

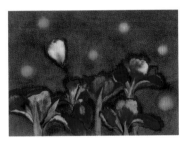

*Iris and the Grasshopper that
Flew Away*
78 x 102 cm, 31 x 41 inches

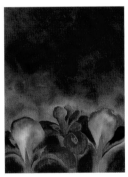

Iris Before the Storm II
77 x 58 cm, 31 x 23 inches

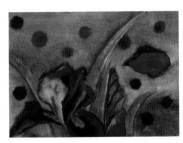

Iris at Dusk II
57 x 77 cm, 23 x 31 inches

2008

2007

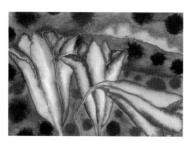

Ode at Twilight VI
34 x 46 cm, 14 x 19 inches

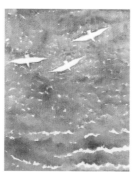

Dream Odyssey Revisited II
68 x 53 cm, 27 x 21 inches

2009

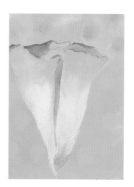

Ascension III
45 x 32 cm, 18 x 13 inches

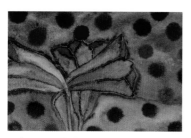

Ode at Twilight VII
34 x 46 cm, 14 x 19 inches

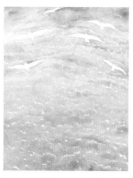

Dream Odyssey Revisited III
68 x 53 cm, 27 x 21 inches

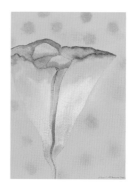

Ascension IV
45 x 32 cm, 18 x 13 inches

2011

2010

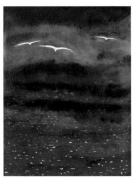

*And Still You Whisper,
Still I Wait, Yet Again III*
77 x 58 cm, 31 x 23 inches

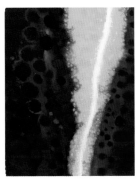

*Ascending Angel
Revisited III*
100 x 75 cm, 40 x 30 inches

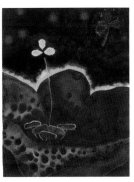

*Twilight of Whispering
Dreams VI*
100 x 75 cm, 40 x 30 inches

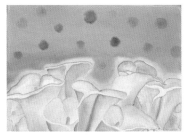

Ethereal Promises IV
57 x 76 cm, 23 x 30 inches

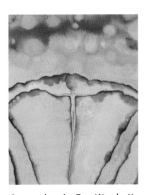

Ascension in Beatitude II
100 x 75 cm, 40 x 30 inches

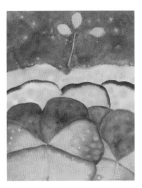

*Whispering Dreams
at Sunset*
101 x 77 cm, 40 x 31 inches

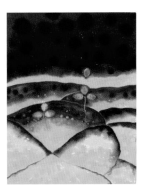

*Twilight of Whispering
Dreams II*
100 x 75 cm, 40 x 30 inches

2012

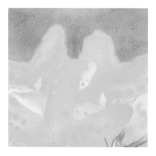

Beatitude in Anticipation
50 x 50 cm, 20 x 20 inches

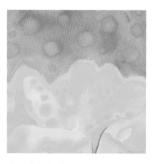

Beatitude in Anticipation IV
50 x 50 cm, 20 x 20 inches

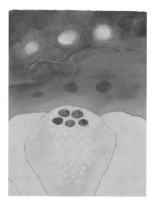

Whispering Dreams at Dawn
77 x 58 cm, 31 x 23 inches

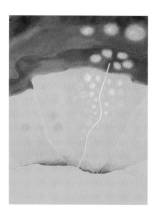

*Whispering Dreams at
Dawn III*
77 x 58 cm, 31 x 23 inches

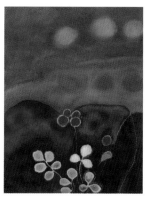

*Whispering Dreams
at Nightfall*
77 x 58 cm, 31 x 23 inches

Public Collections

Grey Art Gallery, New York

The Metropolitan Museum of Art, New York

Fordham University Collection, New York

The Everson Museum of Art, Syracuse

Neuberger Museum of Art, Purchase College, State University of New York

Vassar College Art Museum, Poughkeepsie

Hirshhorn Museum, Smithsonian Institution, Washington DC

Santa Barbara Museum of Art, California

San Diego Museum of Art, California

Las Vegas Art Museum, Nevada

The San Antonio Museum of Art, Texas

The New Orleans Museum of Art, Louisiana

The Minneapolis Institute of Art, Minnesota

Tweed Museum of Art, Duluth, Minnesota

The Aldrich Museum of Contemporary Art, Ridgefield, Connecticut

New England Center for Contemporary Art, Brooklyn, Connecticut

Rutgers University, Camden, Collection of Art, New Jersey

Flint Institute of Art, Michigan

Oklahoma Art Center, Oklahoma City

Washington University Gallery of Art, St Louis

Nelson Atkins Museum of Art, Kansas City, Missouri

Tel-Aviv Museum of Art

The National Council, Kuwait

Centrum Sztuki, Warsaw

Museum of Fine Arts, St Petersburg, Florida

Museum of Arts and Sciences, Daytona Beach, Florida

Springfield Museum of Art, Ohio

Dayton Art Institute, Ohio

Bibliography

Alkazzi, Basil. *Portraits: Strangers No Longer Strangers, Now Acquaintances, Friends, Lovers...* Edited by Henry Riseman. Brooklyn, Connecticut: New England Museum of Contemporary Art (NECCA), 1989.

———. *New Seasons & Dreams 1984-1994.* A visual journey of paintings of a decade. A 21 minute 16mm film. Written, directed, and narrated by Basil Alkazzi. Photographed by Dominic Clemence. London 1994.

———. *Journey To a Land Closer To Heaven.* Narrative with text and photographs of travels in the People's Republic of China and Tibet. London/Tokyo: Izumi Art Publications Ltd., 2008.

Royal College of Art Publication. *The Basil Alkazzi Foundation at The Royal College of Art, Celebration of a Twenty-Year Association, 1985-2005.* London: The Royal College of Art, 2005.

Clemence, Dominic, Producer. *Basil Alkazzi: A Retrospective Journey 1960-2012.* A 20 minute slide show film on DVD of a selection of 220 paintings and drawings. London, 2012.

———. *Basil Alkazzi: Photomontages & Collages.* A slide show film on DVD of Photomontages & Collages 1970-1994. London, 2012.

Kuspit, Donald. *Basil Alkazzi: The Rites of Spring.* Jersey, Channel Islands: Izumi Art Publications Ltd., 2000.

———. *Basil Alkazzi: New Horizons.* Jersey, Channel Islands: Izumi Art Publications Ltd., 1998.

Nalecz, Halima. *Three Decades of Private Views at the Drian.* London: A Drian Gallery Publication, 1986.

Wepman, Dennis. *Resonant Echoes: The Art of Basil Alkazzi.* London/Tokyo: Izumi Art Publications Ltd., 2007.

Whittet, George S. *Mystic Dreamscapes: The Art of Basil Alkazzi.* Brooklyn, Connecticut: New England Center for Contemporary Art (NECCA), 1988.

Wykes-Joyce, Max and Alkazzi, Basil. *New Seasons* by Max Wykes-Joyce & *Within The Dreams* by Basil Alkazzi. Recent Works 1989-1993. Jersey, Channel Islands: Izumi Art Publications Ltd., 1993.

Biographies of the Contributors

Michael L. Royce is the executive director of the New York Foundation for the Arts (NYFA). NYFA empowers artists across all disciplines through cash grants, online resources and professional development training. In his capacity Mr. Royce has also worked with institutions such as the Los Angeles Department of Cultural Affairs, the New Jersey State Council on the Arts, and the Massachusetts Cultural Council, serving on panels that award public dollars to excellent cultural not-for-profits.

Further, he has co-chaired the Grantmakers in the Arts Individual Artists Group Steering Committee and served on the boards of the New York Council of Nonprofits, the Jersey City Museum, the Art Directors Club of New York, and the Rebecca Kelley Ballet.

Prior to his leadership at NYFA, Royce served Governor George E. Pataki of New York State as both president of the Moynihan Station Redevelopment Corporation and as the deputy director of the New York State Council on the Arts, wherein, among his many initiatives, he oversaw the development of the New York–Israel Cultural Cooperation Commission.

Internationally, he was invited by the Japanese Consul of Bahrain to participate in a series of talks aimed at integrating the cultural concerns of the Jewish people living in the Middle East. This invitation was a result of an earlier trip Royce took to Japan as a guest of the Japanese Ministry of Foreign Affairs, in which he consulted with leading political figures on fostering heritage and cultural awareness.

Additionally, Royce has been an invited speaker for the Costa Rica-North American Cultural Center, Arts Council England, the Chinese Bureau for External Cultural Relations, the Arab Fund for Arts and Culture, the Consulate of The Netherlands, and the Instituto Guatemalteco Americano in Guatemala.

As a creative artist, Royce has performed in and directed many theatrical productions throughout the United States. As an administrator, he has been the managing director for the Shadow Box Theatre, the marketing director for the Creative Arts Team, and the Director of Programming for the Theatre Development Fund. He also served as an on-site evaluator for the National Endowment for the Arts from 1993 to 2008, and has received the Ellis Island Medal of Honor for his contributions to the arts.

Judith K. Brodsky is Distinguished Professor Emerita, Visual Arts Department, Rutgers University. She is founding director of the Rutgers Center for Innovative Print and Paper, renamed the Brodsky Center in her honor. Brodsky is co-founder and co-director with Ferris Olin of the Rutgers Institute for Women and Art (IWA). She and Olin are also the founding directors of The Feminist Art Project, an international program to promote women artists in the cultural milieu. Brodsky was the chair of Philagrafika 2010, a city-wide international contemporary visual arts festival in Philadelphia focusing on the printed image; past national president of ArtTable, the College Art Association, and the Women's Caucus for Art; former dean and former associate provost at Rutgers University as well as former chair of the art department at Rutgers/Newark.

Brodsky has organized and curated many exhibitions. With Ferris Olin, she curates the Mary H. Dana Women Artists Series at Rutgers, the oldest exhibition space in the United States showing work by emerging and established contemporary women artists, founded in 1971 by Joan Snyder. The exhibitions they have curated in recent years include a 50-year retrospective of Faith Ringgold's work and *How American Women Artists Invented Postmodernism, 1970-1975*. Brodsky and Olin created the Women Artists Archive National Directory (WAAND), funded initially by the Getty Foundation, a digital directory of archives where the papers of women artists active in the United States since 1945 are located. Among her various writings, Brodsky was a contributor to the first history of the American women's movement in art, called *The Power of Feminist Art* (New York: Harry N. Abrams, 1996).

Most recently, Brodsky was co-curator and co-director of *The Fertile Crescent: Gender, Art, and Society in the Middle East*, a showcase of exhibitions, symposia, lectures, film screenings, musical and literary events by contemporary Middle East women artists, composers, filmmakers, and writers. Brodsky and Olin organized the project and formed a consortium of partners from Rutgers and Princeton Universities. At Princeton University, participating units included the Art Museum, Woodrow Wilson School, and Lewis Center for the Arts; at Rutgers, they included the Zimmerli Art Museum, the Rutgers University Libraries, and numerous Rutgers departments, centers and institutes. Other partners were the Institute for Advanced Study; the Arts Councils of Princeton and West Windsor; and the Princeton, New Brunswick and East Brunswick Public Libraries.

She has received honorary doctorates from Monmouth University and Moore College of Art and Design. Other awards include the Women's Caucus for Art Lifetime Achievement Award and the College Art Association Committee on Women's Annual Recognition Award (now known as Distinguished Feminist Award).

Brodsky serves on the boards of the New York Foundation for the Arts, and the International Print Center/New York.

Brodsky's work is in the permanent collections of over 100 museums and corporations including The Library of Congress; Victoria & Albert Museum; The Stadtsmuseum, Berlin; Grunwald Center for the Graphic Arts, University of California at Los Angeles; Rhode Island School of Design Museum; New Jersey State Museum; and the Fogg Museum, Harvard. She has an MFA from Tyler School of Art, Temple University, and a BA from Harvard University.

In her prints and drawings, Brodsky works with intellectual, political, and social issues. Her images of the environment, women, and family become metaphors for life, decay, death, and possible salvation.

Donald Kuspit, one of the most eminent art critics in the United States, is Distinguished Professor Emeritus of Art History and Philosophy at Stony Brook University, The State University of New York and has been the A.D. White Professor at Large at Cornell University (1991-1997). He is also a senior critic at the New York Academy of Art.

Winner of the prestigious Frank Jewett Mather Award for Distinction in Art Criticism (1983), given by the College Art Association, Kuspit is a contributing editor at *Artforum*, *Artnet Magazine*, *Sculpture*, and *Tema Celeste* magazines, and the editor of *Art Criticism*. He has written numerous articles, exhibition reviews, and catalogue essays and lectured at many universities and art schools. He is the editorial advisor for European Art 1900-1950 and art criticism for the *Encyclopedia Britannica* (16th edition) and wrote the entry on art criticism for it.

Kuspit has received honorary doctorates in fine arts from Davidson College (1993), the San Francisco Art Institute (1996), and the New York Academy of Art (2007). In 1997 the National Association of the Schools of Art and Design presented him with a Citation for Distinguished Service to the Visual Arts. In 1998 he received an honorary doctorate of humane letters from the University of Illinois at Urbana-Champaign. In 2000 he delivered the Getty Lectures at the University of Southern California. In 2005 he was the Robertson Fellow at the University of Glasgow. In 2008 he received the Tenth Annual Award for Excellence in the Arts from the Newington-Cropsey Foundation.

He has received fellowships from the Ford Foundation, Fulbright Commission, National Endowment for the Arts, National Endowment for the Humanities, Guggenheim Foundation, and Asian Cultural Council, among other organizations.

Kuspit has written some of the most influential American art criticism of recent decades. Books published just since 2000 include *The Rebirth of Painting in the Late Twentieth Century* (New York: Cambridge University Press, 2000); *Psychostrategies of Avant-Garde Art* (New York: Cambridge University Press, 2000); *Redeeming Art: Critical Reveries* (New York: Hudson Hills, 2003); *The End of Art* (New York: Cambridge University Press, 2004); in Chinese, University of Peking Press; in Polish, Gdansk Museum of Modern Art; in Spanish, Akal; in Turkish, Istanbul: Metis); and *A Critical History of Twentieth Century Art* (New York and Berlin: Artnet, 2006; ebook). He has also written many essays on artists including the photographer Albert Renger-Patzsch, Karel Appel, Dale Chihuly, Joseph Raffael, Hans Hartung, Mel Ramos, April Gornik, Cristobal Gabarron, Horst Antes, Eric Fischl, Louise Bourgeois, Leon Golub, Alex Katz, Marlene Yu, and of course, Basil Alkazzi.

Kuspit is also the author of three books of poetry: *Self-Refraction* (1983; visual accompaniment by Rudolf Baranik); *Apocalypse with Jewels in the Distance* (2000; visual accompaniment by Rosalind Schwartz); and *On the Gathering Emptiness* (2004; visual accompaniment by Walter Feldman and Hans Breder).

He has doctorates in philosophy (University of Frankfurt) and art history (University of Michigan), as well as degrees from Columbia University, Yale University, and Pennsylvania State University. He has also completed the course of study at the Psychoanalytic Institute of the New York University Medical Center.

Kuspit is on the advisory boards of the Lucy Daniels Foundation, the Philoctetes Society, the Chautauqua Institution, the Gabarron Foundation, and the Rueda Foundation. He has also curated many exhibitions.

Harry I. Naar is Professor of Fine Arts in studio art and art history at Rider University, director of the University's art gallery and curator of the University's art collection. He has been a member of the Rider faculty since 1980. The Rider University art gallery is considered by many to be one of the most important exhibition spaces in the tri-state area (New Jersey, Pennsylvania, New York). Naar presents to the University and the public a wide spectrum of exhibitions and artists' talks. Along with gallery exhibitions, he has conducted interviews and written and published catalogues on numerous artists. He has lectured publicly and has served as a panelist at other educational institutions and for the New Jersey State Council on the Arts.

In 2005, Naar received a grant in printmaking from the Rutgers Center for Innovative Print and Paper (Brodsky Center for Innovative Editions). In 2009 Rider University honored Naar with the Frank N. Elliott award for distinguished service to the University. In 2009 he was selected as one of thirty artists from around the country to exhibit at the Invitational Exhibition of Visual Arts of the American Academy of Arts and Letters where he won the Eugena Speicher, Betts, Symons purchase award. He is listed in *Who's Who in American Art*.

Naar's work has been on view in numerous one-person and group exhibitions throughout the country, among them the Corcoran Gallery of Art; the Canton Art Institute, Ohio; the High Museum of Art; the Boca Raton Museum of Art; the USSR Artist's Union Gallery, Moscow. His work is included in numerous private and public collections, including the American Council on Education, Washington, DC; the New Jersey State Museum, Trenton; the Lyme Academy College of Fine Arts, Connecticut; the Morris Museum of Arts and Sciences, Morristown, New Jersey; The Newark Museum of Art, New Jersey; the Montclair Art Museum, New Jersey; the Jane Voorhees Zimmerli Art Museum, Rutgers University, New Brunswick, New Jersey; the Frances Lehman Loeb Art Museum, Vassar College, Poughkeepsie.

Naar received his BFA from Philadelphia College of Arts (now University of the Arts) and his MFA from Indiana University, Bloomington, Indiana, where he was a fellowship student and teaching assistant. He also studied in Paris, France, where he met frequently with the renowned painter Jean Hélion.

Isabella Duicu Palowitch (born in Brasov) is Hungarian/Romanian in origin. She has exhibited her paintings and drawings in New York, Philadelphia, Paris, Madrid, Vienna, and Bucharest; her work has also appeared in several art publications, and is in private and public collections including the Museum of the American Hungarian Foundation, New Brunswick.

She is the founder and owner of ARTISA LLC, a graphic design firm located in Princeton, New Jersey, and Bryn Mawr, Pennsylvania. She has designed art books and catalogues that sell in major museum bookstores including the National Gallery of Art, Washington, DC; Museum of Modern Art, New York; and in Europe. Palowitch has received awards for design and printing excellence from Graphic Design: USA, Neographics, Benjamin Franklin Premier Print, Astra, *Art Direction* magazine, and CASE Gold Awards. Selected clients include Princeton University (numerous departments, including Art and Archaeology; the Cotsen Children's Library; Office of Information

Technology, where she worked on the design of the University's first website in 1996–98; Princeton University Press; and the 250th Anniversary Celebration Committee); the Princeton Symphony Orchestra (since 1997); the Historical Society of Princeton; and Rutgers University (numerous departments including the Institute for Women and Art, Rare Books Collection, Rutgers University Press, and Jane Voorhees Zimmerli Art Museum).

Most recently, she was the designer and production manager for the book, *The Fertile Crescent: Gender, Art, and Society*, which documented the project described above in Brodsky's biography. The 256-page, fully illustrated and indexed hard cover book contains critical essays, biographies, statements, and bibliographies pertaining to the 24 women artists in the core exhibition which took place at the Princeton University Art Museum, the Bernstein Gallery at Princeton University, The Arts Council of Princeton, the Mason Gross Galleries at Rutgers University, and the Rutgers University Women Artists Series Galleries.

She earned her BFA from the Institutul Nicolae Grigorescu, Bucharest in 1978, and received her MFA from the Mason Gross School of the Arts, Rutgers University in 1984.

Linda Arntzenius was born and raised in Mossend, Scotland and later moved to London where she worked for the Association of Commonwealth Universities in Bloomsbury. She began her writing and editing career in the United States as a staff writer for the University of Southern California (USC) News Service in Los Angeles.

In 1998, she moved to Princeton and taught as an adjunct professor in the departments of English at Mercer County Community College and The College of New Jersey before becoming publications officer at the Institute for Advanced Study (IAS). At the Institute she researched and edited articles for *The Institute Letter* and oversaw the production of print materials including a 40 page illustrated booklet, *Institute for Advanced Study, 1930-2005*, marking the Institute's 75th anniversary. Since 2009 she has been conducting oral history interviews for the Institute's Shelby White and Leon Levy Archives Center.

Arntzenius serves as a contributing editor for the magazines *Princeton* and *Urban Agenda*. Her byline appears regularly in a variety of online and print media including *The Princeton Packet*, *AllPrinceton.com*, and *US1 Weekly*. She is a staff writer with *Town Topics*, Princeton's weekly newspaper where she writes on local history, biography, art, architecture, and literature through feature articles, profiles, and interviews.

Her published works include the pictorial history: *Images of America: Institute for Advanced Study*, Arcadia Publishing, 2011; and *The Gamble House*, a booklet about the National Historic Landmark by Arts and Crafts architects Charles and Henry Greene, published by the USC School of Architecture, 2000.

A member of the Society of Professional Journalists, the American Society of Journalists and Authors, and the International Oral History Association, Arntzenius' awards include a 2010 New Jersey Excellence in Journalism Award and a 2004 APEX (Awards for Publication Excellence).

Also a poet, she is a member of US1 Poets' Cooperative with poems in literary journals in the United States; several have been awarded honorable mentions by the New Jersey Writers Conference and the Allen Ginsberg Poetry Awards.

She has a BA (First Class Honors) in Studies in the Humanities from the University of Hertfordshire and a MSc in Logic and Scientific Method from the London School of Economics and Political Science. She also has a Postgraduate Diploma in Computer Science from Birkbeck College, London University and a Master of Professional Writing (MPW) from the University of Southern California.

Greg Leshé is an interdisciplinary artist, photographer, educator, and curator. He was born in Natchitoches, Louisiana and grew up in northern New Jersey where he now lives. Leshé is a member of the faculty at Kean University's Robert Busch School of Design, teaching courses in art and design. He also teaches photography to students worldwide, in one of the largest online BFA programs in the country, offered through Academy of Art University in San Francisco.

His autobiographical works explore the links among memory, the body, and self-performance. Through his writings, sculptures, photographs, performances, and video installations Leshé explores dreams, memories, life-defining events, and experiences with family, aviation, manual labor, masculinity, violence, and obsession. His art has been exhibited nationally and he has been designated a distinguished artist for his work in photography, video and performance by the New Jersey State Council on the Arts, Department of State. Recent exhibitions include a solo exhibition, *Ground-over Skies, A Decade of Interdisciplinary Work in Video, Photography, Writing, Performance and Installation* at Gallery Aferro, Newark, New Jersey, 2010; *Persona, Externalizing the Psychological Self*, Therese A. Maloney Art Gallery, College of St. Elizabeth, Morristown, New Jersey, a group show curated by Virginia Fabbri Butera, 2013; and also in 2013, *Toxicity* at the Williamsburg Art and Historical Center, Brooklyn, New York, a group show of seven contemporary artists who are addressing the subject of toxicity and its widespread effect on society, the environment, political and corporate institutions, and the individual, curated by Aimée Hertog.

In addition to his personal creative work, Leshé works on photographic assignment and has produced award winning projects for a wide range of clientele, including creative agencies, design firms, art directors, artists and galleries, educational institutions and publications. He specializes in lifestyle and portraiture. Former and current clients include Audiofile, Chubb Insurance, Met Life, Pershing, Prudential, Sharp Electronics, Seton Hall Law School, and Vicinity Media. Leshé also works with artists and art institutions such as Robert Morris/Sonnabend Gallery and Aljira, A Center For Contemporary Art, providing photographic and imaging services to help bring their work to greater public view.

Leshé earned a BFA in sculpture and photography from Alfred University and attended New York University and the International Center of Photography, receiving an extended MA degree in photography and interdisciplinary art through their combined program.

Credits

Published in conjunction with the traveling exhibition,
BASIL ALKAZZI
AN ODYSSEY OF DREAMS: A Decade of Paintings 2003-2012.

Curator: Judith K. Brodsky

Exhibition venues:

 The Bradbury Gallery, Arkansas State University, Jonesboro | August 29 – September 29, 2013
 The Anne Kittrell Gallery, University of Arkansas, Fayetteville | November 4 – December 6, 2013
 Rider University Art Gallery, Lawrenceville, New Jersey | February 6 – March 2, 2014
 The Rosenberg Gallery, Maryland Institute College of Art, Baltimore | March 22 – April 20, 2014
 The Sheldon Museum of Art, University of Nebraska-Lincoln | May 16 – July 27, 2014

ISBN: 978-1-85759-876-6

Published in 2013 by
Scala Arts Publishers, Inc.
141 Wooster Street, Suite 4D
New York, NY 10012

www.scalapublishers.com

Cover

Front: *Ascension in Beatitude II*, 2011, detail, gouache on hand-made paper, 100 x 75 cm, 40 x 30 inches.
Back: *Ascension in Beatitude II* detail reproduced at original size.

Production

General Editor: Judith K. Brodsky
Catalogue design and production management: Isabella Duicu Palowitch, ARTISA LLC
Copy editing: Linda Arntzenius
Typesetting: Margaret Trejo
Photography: Greg Leshé

Fonts: The Sans and ITC Slimbach families
Paper: GoldEast matt art
Printed and bound in China